A Singular People: Images of Zoar

A SINGULAR PEOPLE

Images of Zoar

KATHLEEN M. FERNANDEZ

The Kent State University Press Kent & London

© 2003 by The Ohio Historical Society

All rights reserved.

Library of Congress Catalog Card Number 2002031277

ISBN 0-87338-767-8

Manufactured in Canada.

07 06 05 04 03 5 4 3 2 1

Library of Congress Cataloging-in-Publication Data

Fernandez, Kathleen M., 1949–

A singular people : images of Zoar / by Kathleen M. Fernandez.

p. cm.

Includes bibliographical references (p.).

ISBN 0-87338-767-8 (cloth : alk. paper)

1. Zoar (Tuscarawus County, Ohio)—History—Pictorial works. I. Title.

F499.Z63 F47 2003

977.1'66—dc21

2002031277

British Library Cataloging-in-Publication data are available.

To the people of Zoar, past and present

Weaving House

Meeting House

School

Log House Log House Bakery

Fourth Street

Gardener's House
& Greenhouse

Log House Log House

Tinsmith Shop

Garden

Farmers'
House

Sewing House

Third Street

Bimeler
House

Number One House

Cobbler Shop

Barns, Tannery, & Granary

Foltz Street

Town Hall

Park Street

Main Street

Second Street

Parking

Cow Barn

Store

Hotel

Livery Barn

Cider Mill &
Carpenter Shop

Parking

First Street

Parking

Wagon Shop

Blacksmith Shop

Mills & Dye House

■ — Buildings owned by The Ohio Historical So-
ciety and open to the public.
▨ — Privately owned buildings and Ohio Histori-
cal Society buildings not yet open to the public.
□ — Location of original Zoar buildings no longer
in existence.

Contents

A Note About the Ornament

The seven-pointed Zoar Star became the symbol of the Zoar Separatists while they were still in Germany. Emblematic of the Star of the Bethlehem and the light of God in us all, the original stars, made of fabric and wrapped with silk thread, were used as a badge to identify members of this dissenting sect. Believers were punished by the authorities for wearing this tiny symbol on their bonnet strings or lapels, as it showed defiance of the rule that all must worship in the established Lutheran Church. After their arrival in America, the star became the emblem of the communal Zoar Society and is depicted today in the ceiling of Number One House and in flowers in the Garden. An acorn, symbolizing fruitfulness and success, was added in the center.

Preface and Acknowledgments

"And what and where is Zoar?" asks some curious reader. Well, Zoar is the quaintest, most interesting and most absolutely unique village. . . . It is situated in Tuscarawas County, Ohio, and is owned and occupied exclusively by a most singular set of German pietist-mystics, socialists and communists, known as Zoarites who founded it in the year 1817.
— Geoffrey Williston Christine, "Zoar and the Zoarites,"
Peterson's Magazine (January 1889)

Thus begins a description of the author's sojourn in Zoar. *Peterson's*, the *Ladies Home Journal* of its day, was one of many magazines and newspapers that printed articles on this picturesque German community. These articles help us today to form a picture of what life was like in nineteenth-century Zoar from an outsider's perspective.

Historic sites that endeavor to understand and explain to others how life was lived in an earlier time, especially a people with such a distinctive lifestyle as the communal Zoar Separatists, need to provide as much as possible about the minutiae of everyday life. These so-called first-person accounts left by scholars, journalists, diarists, and others help us to understand and to interpret the essence of life in Zoar to our visitors.

Zoar, a former German communal society founded by religious dissenters in 1817, has been a magnet for tourists and travelers almost since its beginnings. The community consciously kept its German roots and so, in the words of George

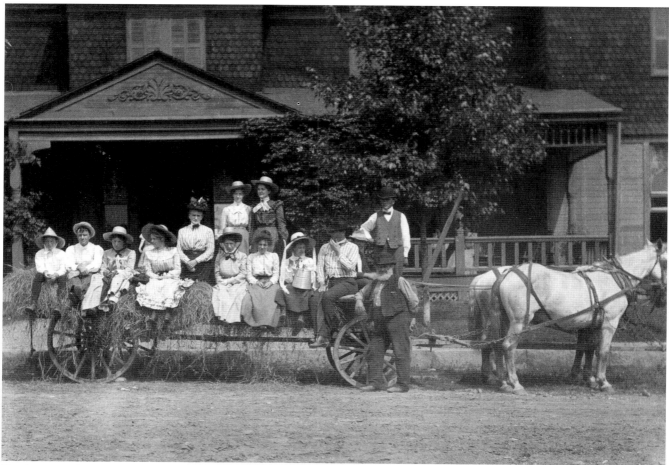

Hotel guests pile on a hay wagon in front of the 1892 Zoar Hotel addition. *P365 Properties Collection.*

Washington Hayward, one of the earliest of Zoar visitors, remained "a singular people," one who attracted the curious individual, the traveler, the day-tripper, and the magazine and newspaper writers of the day.

Due to its Old World character and its tourism, the village was well photographed, especially after amateur photography became popular in the late nineteenth century. Tourists snapped themselves sitting on hay wagons, boating on Zoar Lake, or walking in the Separatists' symbolic Garden. The Zoarites themselves got into the act as well, taking commercial photos of themselves and their town to be sold as postcards to these same tourists.

The aim of this book is to pair these two media: the images of the mind, written by outsiders, and the images of the camera's eye. Both can tell volumes to today's visitor about what life was like—or what it was perceived to be—in the experiment in communal living that was Zoar, Ohio.

This is a book that has called my name ever since I came to Zoar, now more than twenty-six years ago, and it has been a pleasure to write it.

I'd like to thank the staff of the Ohio Historical Society, especially my former boss, Bill Schultz, and my present one, Steve Henthorne, for giving me the time out of my regular schedule to work on this book. I also wish to thank the audio-visual staff at the Ohio Historical Society Library, Cynthia Ghering and Lisa Wood, for making it so easy for me to locate the photos and duplicate them. Thanks also to Bill Gates and Susan Goehring for reading the manuscript. I'm grateful to retired colleague Don Hutslar, who trolled his prodigious memory for names and dates of sources. Thanks to my staff at Zoar, especially Melanie Eddy and Cass Noturno, for putting up with my absences—and absentmindedness—while writing this.

Thank you to the librarians at the Cleveland Public Library and Cornell University Library for granting permission to use material.

The real thanks goes to those who created the marvelous collection of Zoar photographs, especially Louis Baus, who almost single-handedly preserved the bulk of Zoar photographs by obtaining originals from Zoar residents, copying and pasting them into meticulously kept albums, and writing down the details they preserved. All of the photos in this book, except one, are within the collections of the Ohio Historical Society.

This interpretation of Zoar would be poorer if it weren't for the newspapermen and -women, diarists, tourists, and other observers who came to this interesting village to write about it. If it were not for their acute comments and knowing eye for detail, we would know very little about how Zoar looked, at least to others. I hope this book accurately pairs their visions with those of the camera to give a complete view of late-nineteenth-century Zoar. I also extend grateful thanks to the fascinating people of communal Zoar, who made such an intriguing—and singular—community that the writers and photographers cited here wanted to document it.

My final thanks go to my husband, Jim Hillibish. Maybe after twenty-five years of marriage your writing talent has rubbed off on me.

A Brief History of Zoar

The Founding of Zoar

The village of Zoar, located on the Tuscarawas River in east central Ohio, was founded in 1817 by a group of German religious dissenters who emigrated from their native Württemberg in southwest Germany, near Switzerland.

The Duke (later king) of Württemberg was Lutheran, and, as was the custom in the days before German unification, therefore so were all his subjects, whether they liked it or not. These dissidents, who called themselves Separatists because they wished to "separate" from the formalized Lutheran Church, were Pietists. Originating in the late seventeenth century, Pietists sought to reform the Lutheran Church from the inside. Pietists later formed a Radical branch that wanted a complete break with Lutheranism, and it was to this branch that the future Zoar Separatists belonged. This group of dissenters, centered in many tiny villages around the Stuttgart area, coalesced about the year 1800. Their beliefs were more mystical than most Pietists; they believed in the radical teachings of the shoemaker Jakob Boehme (1575–1624), and that the Lutheran Church was hopelessly corrupt, and that they should be able to worship God in their own way.

Because the state and the church were so intertwined—the state church also ran the schools and performed civil ceremonies—Radical Pietists such as the Zoarites were forced to refuse to attend church, to send their children to church-run schools, and, despite their pacifist beliefs, to serve in the army. Obligatory military service was an important governmental prerogative in this time of the

Immigrants from Württemberg to Zoar were given passports like this. *MSS770 Zoar Papers.*

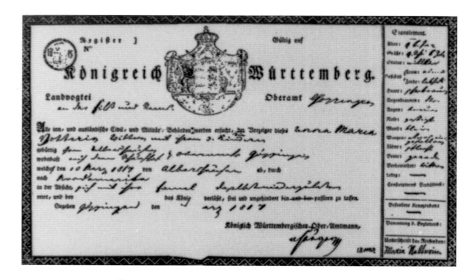

Napoleonic Wars, which involved Württemberg and other small German states. Because of their refusal to obey, male and female Separatists were flogged, imprisoned, and had their lands confiscated and their children put in orphanages.

When the old king died, his son and successor pardoned the Separatists, some of whom had been jailed for more than ten years. After an aborted attempt to move to an abandoned estate in Brandenburg in eastern Germany, the Separatists were allowed to emigrate in 1817, this time to the United States, where the new U.S. Constitution's First Amendment pledged that anyone, immigrants included, would be allowed to worship as they wished.

Word of the Separatists' plight reached English Quakers, who not only gave funds for ship's passage to the three hundred Separatists who wished to leave but also sent letters of introduction to their brethren in Philadelphia. After an arduous journey of ninety-three days, the *Vaterslandliebe* ("love of the fatherland") docked in Philadelphia in August 1817. The local Quakers fed, clothed, and found jobs and housing for the refugees and attempted to find property nearby on which they could settle.

Joseph Michael Bäumeler (later Anglicized to Bimeler) had become the leader of the group during the journey. Originally a weaver and then a schoolmaster and a homeopathic doctor, Bimeler was also an astute businessman

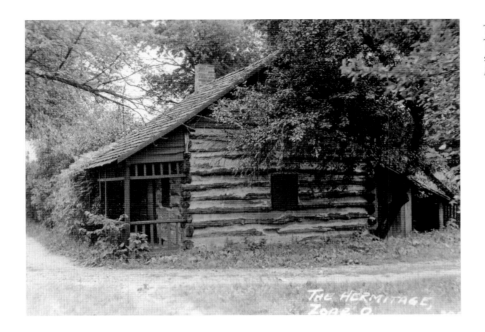

The Separatists originally built log houses. This is the Hermitage, one of five log structures still standing in Zoar. *P223 Baus Collection.*

and a charismatic preacher well versed in Radical Pietist teachings. Bimeler had no patience with the well-meaning Quakers and quickly found a German land agent, Godfrey Haga, who had acreage for sale in far-off Ohio.

The group, with Bimeler as their agent, purchased 5,500 acres on the Tuscarawas River sight unseen for $16,500, a price to be paid over fifteen years. The generous Quakers lent the Separatists funds for the down payment as well as money for transportation to Ohio.

In November Bimeler and a few able-bodied men traveled to the new lands. They were impressed with their purchase. The land was hilly and heavily wooded but also had cleared fields (formerly cultivated by the Indians) along the river's edge that were ready for immediate use. They picked a town site where seven springs provided enough water to supply the population. They called the town Zoar after Lot's biblical refuge (Genesis 11)—as indeed it was for them a refuge as well. The town was platted, with inhabitants going to their outlying fields in the European manner. The first cabins were constructed in preparation for the remaining Separatists, who arrived in small groups that spring.

The first months were difficult, with bad weather, poor crops, and no cash; some were forced instead to work for nearby outsiders. They soon found that a cooperative system was needed. In April 1819 a communal system was suggested in which all would work for the benefit of the whole. Initially Bimeler opposed the proposition, as he thought members could not subject themselves to the sacrifices it entailed. However, the will of the majority prevailed, and Bimeler wholeheartedly gave his support. It was due to his business acumen and influence that Zoar prospered.

The new organization of the community was simple and democratic. Members, males over age twenty-one and females over eighteen, signed a pact renouncing "all and every right of ownership . . . of property" in favor of the Society and agreeing to "render due and faithful obedience to the orders and regulations" of the officers elected by the Society. In return, members were provided with all the necessities of life.

Three Trustees were elected every three years, with men and women having equal political rights. There was no bar to women holding office, although none ever did. A standing committee of five provided a check on the actions of the Trustees. Terms for an Agent General, Joseph Bimeler (the office was abolished after his death), and Cashier were also provided for. The Trustees ruled over every aspect of Zoar life, including all Society lands and enterprises; the assignment of tasks; the provision of food, clothing, and shelter; and the maintenance of order. One Trustee was placed in charge of agriculture, another industries, and the third livestock and, later, the Zoar Hotel. This organization remained in place with very few changes until the Society's dissolution in 1898.

A second constitution in 1824 expanded these rights and responsibilities, and a third (and last) in 1833 incorporated the group under the laws of the State of Ohio as "The Society of Separatists of Zoar" and provided for a probationary class. Newcomers could join the Society, but membership was restricted primarily to German-speakers, most of whom had ties to Pietist groups overseas. However, two former Shakers, Amasa Blodgett and Mary Scott, did join; presumably their familiarity with communalism outweighed their "Englishness."

Provision for withdrawal was made in the constitution by means of a quit-claim, which stated that no restitution would be made to those who withdrew from the Society. (This point was definitively made in a U.S. Supreme Court

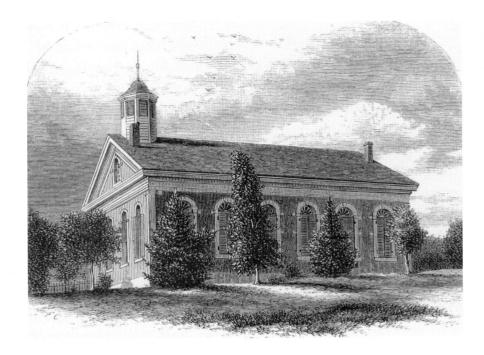

In 1853 the Separatists built a new Meeting House, illustrated here in Charles Nordhoff's 1874 book on communal societies that garnered a good deal of attention for Zoar. From Nordhoff, *Communistic Societies of the United States* (1874).

decision in 1853.) However, in practice most seceders were given their clothing and some furniture. The constitution provided for settlement of disputes, but peer pressure usually prevailed. If not, public reprimands in church were given, with expulsion from the Society as a last resort.

The Separatists' religion was as simple and direct as the people themselves. They had an abiding belief in the Bible and endeavored to maintain a direct relationship with God. They believed in the imminent return of Christ to establish his kingdom on earth and that each individual must experience a spiritual rebirth (*Wiedergeburt*) by purging himself or herself of evil and being a living example of virtue.

Their services were bereft of all ceremony, with nothing that resembled the established church. Bimeler gave talks called "discourses" (not sermons) that delved deeply into the arcane theology of German mystics Jakob Boehme, Jakob Spener, and Gerhard Tersteegen. Bimeler's extemporaneous discourses were transcribed by a congregation member for his deaf father and later printed for the community after the leader's death in 1853.

Sundays were devoted to worship, with the main service in the morning,

which consisted of a discourse and many hymns. Prayer was silent. A choir led the singing and was accompanied by musical instruments and, after 1873, a pipe organ, which is still used today. Scripture was studied in the afternoon, and the evening service featured readings of the German mystics. However, if farm work was pressing, as at harvest time, Sundays could be devoted to work, because to the Separatists one day was as holy as another.

Everyday Life in Zoar

Work was also held in high esteem. Each member, including women, received their assignments from the Trustees. Craftsmen, such as the tinsmith, usually did the same job each day, with general laborers getting new assignments each morning. A bell was rung at the Assembly House at daybreak so all could gather to hear the orders for the day. Women worked alongside men in the fields and performed many heavy tasks, including the hand threshing of grain.

The labor of Zoar's women, who outnumbered the men two to one in the initial party, was crucial to the success of the community. Their work was so important that in 1822 a momentous decision was made—to become celibate. In the Separatists' religious hierarchy, celibacy was regarded as adhering to a higher standard. Not being involved in sexual commerce brought one closer to God, a belief reflected in the Separatists' Principles.[1] Besides, the labor of all was sorely needed to survive, and the community could not spare its women for childbearing and rearing, so the move had an economic as well as religious basis.

With the celibacy mandate households were divided by sex, with already-married men and women living apart. Male households included a female housekeeper, and young male children lived with their mothers. To all accounts this unusual lifestyle was accepted by the entire community. The experiment ended in 1829 with the marriage of cabinetmaker Jakob Fritz, soon followed by other marriages, including that of Joseph Bimeler, a widower. By this time the community had gotten on its financial feet and the economic need for celibacy had been eliminated.

1. Separatist Principle Number 8: "All intercourse of the sexes, except that which is necessary for the perpetuation of the race, we hold to be sinful and contrary to the command of God; entire abstinence, or complete chastity, is, however, still better." Quoted from Edgar B. Nixon, "The Society of Separatists of Zoar" (Ph.D. diss., Ohio State University, 1933), 14.

Communalism required all to work together for the benefit of the whole. *P223 Baus Collection.*

In 1827 the Society contracted with the State of Ohio to build the seven miles of the new Ohio & Erie Canal, whose route ran across its lands. Zoar men and women worked together digging by hand, the women even carrying dirt in their aprons. The canal was a boon to the group; it not only enabled them to pay off their land, but it also gave them ready access to markets for their agricultural products and manufactured goods as far away as New York City, St. Louis, and New Orleans.

By 1834 Zoar was a thriving community. Bimeler, in a letter that year to U.S. Postmaster General William T. Barry, described Zoar:

The village of Zoar is situated about 9 miles directly north of New Philadelphia, the seat of justice of the county of Tuscarawas, and about 1/2 mile east of the Ohio canal and the Tuscarawas River; it is principally inhabited by Germans, and contains at present about 300 souls. The improvements in and near the village consist chiefly in: 1 flouring-mill, 2 saw-mills, 1 oil-mill, 1 woolen and linen manufacturing establishment; 1 warehouse; 1 new and commodious hotel; 1 store, and various other places of industry and mechanical business. There is also a blast furnace building at this time by the society of Zoar, situated about 2 miles north of the village on the Ohio canal. The north-west square of the centre of the village presents to view a delightful garden and a middle-size green or summer-house, comprising a choice selection of fruits, plants, shrubs, flowers, etc. A mineral spring about 1 miles east of this place is said to contain excellent medicinal qualities, for the better use and improvement of which, a house is erected over it. The face of the country is generally rolling, interspersed with some flat plains; water good. The chief products of the soil are wheat, rye, corn, barley, oats, flax and hemp, wheat is the staple article. Horses, cattle and sheep are improving. The more hilly part of the country in the vicinity or the village contains considerable deposits of iron ore, which is being mined and which is daily hauled to the banks of the Ohio Canal, from thence shipped on board of canal boats to the several blast furnaces north and south, distant of from 18 to 150 miles. Stone coal is also found among the hills, yet, not in such quantities as iron-ore.[2]

Only weeks after this glowing description was written, however, cholera broke out in Zoar, carried by a traveler on a passing canal boat. When the epidemic ended a month later, a third of the community had perished, including many children and young people. Although devastated by their loss, the community continued, with Bimeler's business leadership involving the group in such enterprises as iron making, railroads, and land speculation.

The village, as the travelers' accounts quoted herein attest, was neat and well kept. Even the tree trunks were scrubbed. The streets were lined with apple trees and homes were surrounded by picket fences, colorful flowers,

2. Ibid., 37.

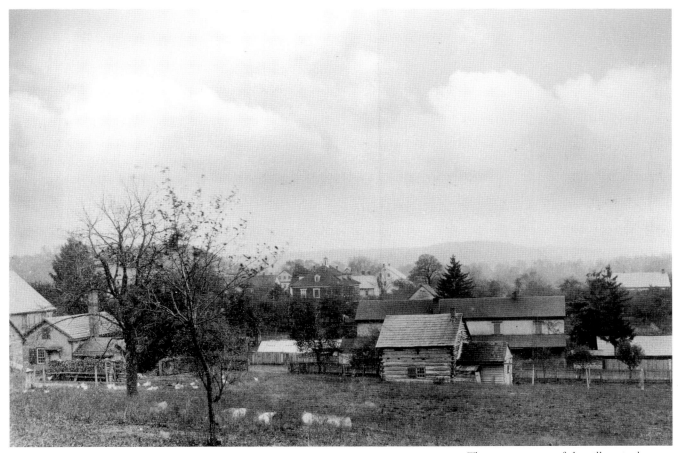

The compactness of the village is shown in this view looking south. The Bakery is on the left and the Joseph Bimeler cabin is in the center, with the Garden House below it. Number One House and the Hotel are in the center-left distance. *P365 Properties Collection.*

and grapevines that trained up the outer walls. Life in Zoar was pleasant. Music, vocal and instrumental, accompanied most activities. Chores such as apple butter making, hops pulling, and corn husking were made social events as well. Zoar homes reflected their German heritage with their red-tile roofs and Old World construction. Rooms were brightly painted. Religious frakturs painted by the Zoar Artist (probably Thomas Maier, 1776–ca.1850) hung on walls surrounded by sturdy Zoar furniture.

The most notable feature in Zoar was its Garden, which occupied an entire block in the center of the village. Symbolic of the New Jerusalem as described in Revelation 21, the Garden's geometrical paths promised ways to

salvation, symbolized by a towering Norway spruce at its center that represented Christ. The accompanying Garden House stored varieties of exotic plants in its "hot house," including orange and lemon trees, which were unfamiliar to most nineteenth-century visitors.

Industry in Zoar followed the village's agricultural bent. In addition to two iron furnaces, Zoar Furnace northwest of the village and Fairfield Furnace to the south, the Separatists had a large flock of sheep that produced wool that was spun and manufactured into fabric, intricately woven coverlets, and blankets, some of which were sold to the Union Army during the Civil War. Farm products, flour, hides, rope, cheese, and butter were all produced for sale as well as for use by the community. Flour, Zoar's most important product, was ground at two different mills, one a towering structure that spanned the canal.

After marriage was reinstated, the resultant children were housed in a nursery (*kinder anstalt*) after age three. This freed their mothers for other work. The matrons who ran these dormitories were strict, and the children were assigned arduous work details plaiting straw for hats and hand-spinning wool for knitting. By 1840 the nurseries were optional, and by 1860 they were defunct.

The Zoarites had their own school, the last built in 1868, which still stands. They leased it to the township, which hired the teachers. (Often teachers were Society members, who turned over their salary to the Trustees.) The Separatists' one requirement was that instruction be at least partially in German, which was taught, together with English, until 1884. Students remained in school until age fifteen and were taught "the 3 Rs" plus music. As was common then in rural America, classes were held about five months a year, with long spring and fall vacations freeing up the students for agricultural work.

Zoar operated, internally at least, as a cashless society. If you were a member or a child of a member you received all you needed to live—food, clothing, and shelter. If you needed something extra you requested it from the Trustees, a step many members were loath to take. The numerous outsiders who worked for the Society were paid partly in cash and partly in trade at the Store. Goods were distributed to members at the Magazine (storehouse) each Friday. Bread and milk were given out daily at the Bakery and Dairy. Each kept an eye on his fellow member, which minimized disputes over equality. Wastefulness was *verboten*, especially if seen by your neighbor, who might report it to the Trustees.

Outside trade was brisk, with the Society selling what it produced and buying those items it could not. The Society used merchant bankers in New York to

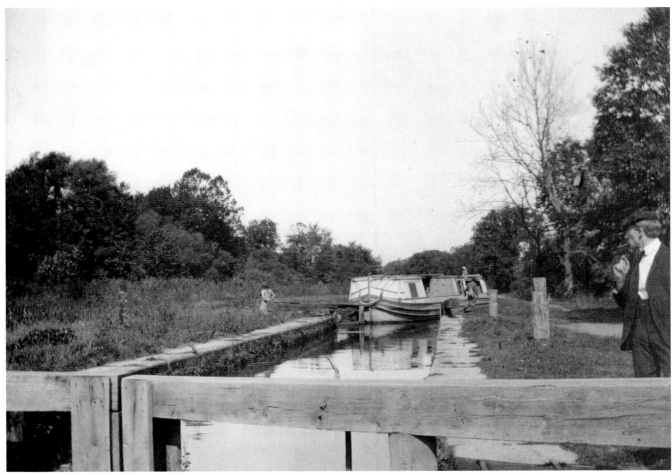

A canal boat approaches the lock gates.
AV9 Collection.

sell its goods to others and used the cash to fulfill the Society's orders for supplies, which were shipped back to Zoar on the canal and, later, the railroad.

By 1852 the Society had reached its zenith in wealth and innovation; its property was valued that year at more than $1 million. Membership had climbed to almost five hundred. However, the next year the charismatic Joseph Bimeler, who had spearheaded the growth, died. Although his successors were honest and well meaning, no one was ever able to take his place, in either the business or spiritual world.

Moreover, the Civil War proved that the Separatist principle of pacifism

could not hold in the face of patriotism. Fourteen young men joined the Union Army in defiance of their parents' pleas. The younger generation lacked their elders' experience with war. Twelve of these men survived, and most returned to communal Zoar, but the Society was changing.

Decline and Dissolution

Zoar experienced a steady decline in the years after Bimeler's death. The commitment to keep the community strong, the willingness to sacrifice, and the strong religious beliefs all began to wane. Initiative was throttled as the group began looking backward instead of forward.

Church attendance declined when no one could capture the spark of Radical Pietism. Memories of persecutions in Germany started to fade as older members passed away. Services degenerated into rereading Bimeler's discourses, and by 1892 more than two-thirds of the membership no longer attended church.

The Society failed to keep pace with the outside world in both agriculture and industry. Society enterprises lost money, and without capital Zoar could not keep up with post–Civil War innovations. Bookkeeping was lax. Members no longer wished to work so hard. Younger members left for the outside, and their resultant successes contributed to even more discontent inside the Society.

The Society's lack of income was somewhat offset by the village's burgeoning tourist industry. The Separatists had long seen the merit of making money from visitors; the first inn on the canal had opened in 1832 and the Zoar Hotel in 1833. But with the coming of the Wheeling & Lake Erie Railroad right into Zoar in 1882, visitors came by the railroad carload, and the resulting income helped keep the community afloat. To capitalize on this, in 1892 the Society enlarged the Hotel with a Victorian addition that doubled its size. However, the tourists, with their ready cash and worldly ways, only made the members feel even more disaffected. An underground economy sprang up as waitresses' tips and egg money bought luxuries unavailable at the Store or Magazine.

In response Levi Bimeler, great-grandson of Joseph and the schoolmaster, started a subversive newsletter in 1895 advocating dissolution of the community. It was called *The Nugitna* ("anti-Gun[n]" backward) and only saw three issues. The title referred to Alexander Gunn, a wealthy Cleveland merchant who lived in high style among the Separatists. He had been sold or leased (records are unclear) a Zoar cabin, the Hermitage, and hosted the Trustees at lavish parties.

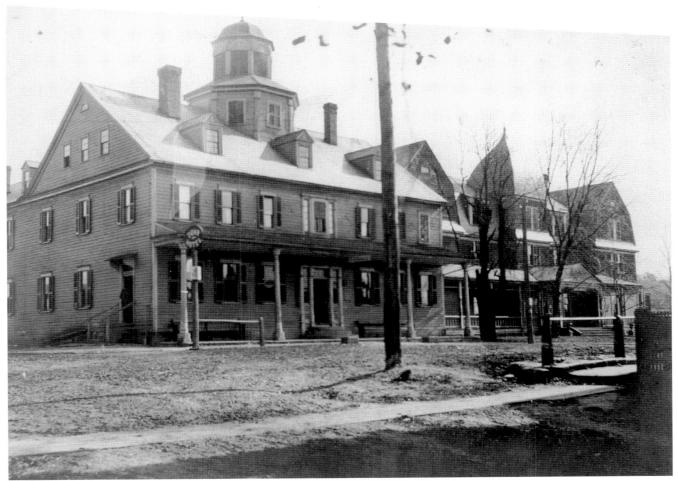

The expansion of the Zoar Hotel in 1892 brought both cash and crisis to the Society. *AV Collection.*

Levi Bimeler complained that Gunn's presence was a sign that the system no longer worked and that it was time to end the communal experiment.

Bimeler's call for dissolving the Society of Separatists was only a bit premature. In March 1898 the Society members formally decided to disband. Outside surveyors were hired to divide the real estate, and a huge auction in October sold the community goods such as livestock and farm equipment. Each member was allowed to keep his or her home, or portion thereof, as some houses were divided internally, just as they had been during communal

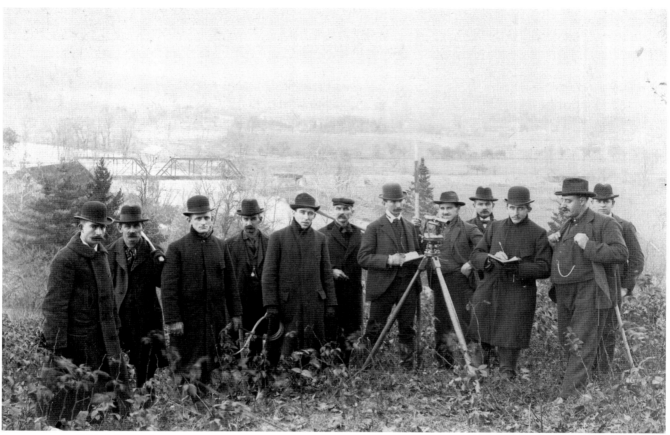

A survey team divided the Society property for the 1898 Dissolution. *AV9 Collection.*

days. The sale proceeds were parceled out, with each member receiving about $200 in cash as well as a piece of real property. Some received ongoing businesses, like the Bakery or Hotel.

Unlike many other communal societies, Zoar still had a sizeable membership (222) at Dissolution, and there was little disagreement with the division of property. Naturally, older members took it the hardest, while some younger folks reveled in their newfound private property rights. E. O. Randall, director of the Ohio State Archaeological and Historical Society (predecessor of the Ohio Historical Society, today's administrator of Zoar Village State Memorial), visited the village right before dissolution and again a year later. He wrote of his second visit:

"Is that your house?" I asked two or three, and with a contented expression that would fairly beam they would utter the possessive "mine.". . . As a fellow visitor and myself stood upon the porch, the husband of the woman drove up with a new buggy and dapper horse. "Where did your husband get that fine rig?" I shall never forget the tone of self-satisfaction with which she promptly replied, "That is OURS—we bought it; isn't it nice to have your own horse?"[3]

Zoar in the Twentieth Century

The villagers of Zoar now had to make their own way without the protective umbrella of the communal Zoar Society. Some sold out right away and left the area; others, who had received established businesses like the Hotel and flour mill, stayed and did well. However, the majority of former Separatists had to scratch out a living as best they could, some by renting out their farmland and others by commuting to jobs in Canton or New Philadelphia.

The Dissolution had left the Town Hall, School, and Meeting House as "corporate" property belonging to the village, which had incorporated in 1884. The School remained leased to the township, and the Town Hall remained the seat of government. However, the Meeting House was another story. For three years the populace dickered over what to do. Some former members even considered becoming Lutherans again, a move most thought too anticlimactic. The problem was solved when Reverend Theodore Merten, who pastored the nearby Bolivar German Reformed Church, agreed to take the Zoar Church as well. He could preach in German, a prime consideration as some former members were not very fluent in English. Therefore, the Zoar Meeting House became a church, with all the attendant ceremonies that the earlier Separatists had shunned. The first confirmation class graduated in 1907. The church continues today as the Zoar United Church of Christ.

The Hotel kept attracting both long-term visitors and day-trippers. Artists, many from Cleveland, came to paint the picturesque landscapes. Some homeowners sold their red-tile roofs to outsiders, replacing them with slate. Although many older people remained, most of their children left to make their

3. E. O. Randall, "The Separatist Society of Zoar," *Ohio Archaeological and Historical Society Quarterly* 8 (July 1899): 75.

way in the world. This first noncommunal generation seemed a bit ashamed to be from Zoar, and many could not wait to get away.

In the mid-1920s the federal government developed a plan to create a flood control district, so the massive destruction seen along the state's rivers in 1913, which ended any further use of the Ohio & Erie Canal, would not be repeated. Their first plan for Zoar as well as other nearby villages was to move the buildings to higher ground. This idea horrified the Zoar residents and made them reflect on their heritage. "We can't move Zoar," they said. "Something important happened here."

The flood control plan had two outcomes that still resound in today's Zoar: one, the U.S. Army Corps of Engineers instead proposed an earthen levee to surround and protect the town; and two, the townspeople got together and restored the central Zoar Garden. The levee, although protecting the residential area, obliterated the surrounding industrial buildings, which had by then become derelict, and cut off the town's view of the nearby river and canal. It also limited Zoar's growth outward.

The Garden restoration had even greater consequences for the future of Zoar. The Garden had been neglected for much of the past thirty years—vegetables had been raised there, the Hotel erected grass tennis courts there for a while, and only some of the perennials still flourished—but the residents wanted it to again be the town's focus. Everyone pitched in—the Sunday school, the Grange, schoolchildren, and assorted residents. The beds were relaid and flowers and trees were planted; it again became "the Garden of happiness."

This successful cooperation led to the formation of the Zoar Historical Society in 1930, and its successor the Zoar Foundation in 1936. Former Zoar members and their descendants raided attics for furniture and other Zoar-made artifacts to create a museum in Number One House, formerly home to Joseph Bimeler and later other Trustees. These items make up the core of the collection currently on display at Zoar Village State Memorial. The Ohio State Archaeological and Historical Society (OSAHS) became involved with the group, first to advise on establishing its museum and later to help finance the purchase of Number One House from its owners. In 1941 Number One, the Garden, and the unrestored Garden House were conveyed to the State of Ohio, and Zoar became a state memorial administered by the OSAHS. Other buildings were acquired, including the Bimeler Museum and its contents, which were bequeathed in 1942 to the OSAHS by descendant Lillian Bimeler

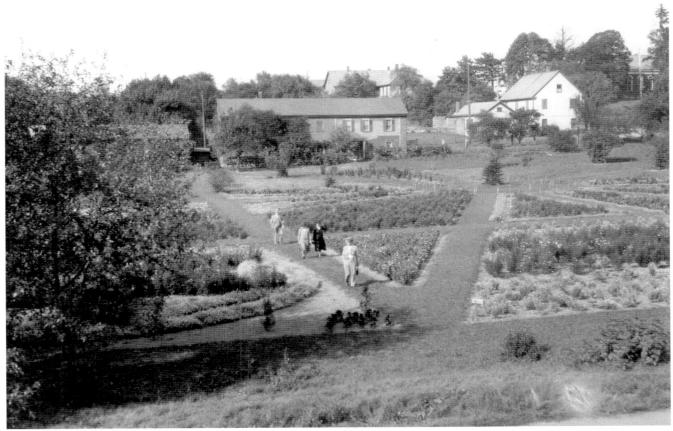

The restoration of the Garden led to Zoar becoming a historic site. *P223 Baus Collection.*

Sturm. The state also acquired the sites of the Tin Shop, Wagon Shop, and Blacksmith Shop in the 1940s. Private restoration occurred in the 1930s with the rehabilitation of four original log cabins by descendant Paul Rieker.

The Great Depression of the 1930s fairly eliminated what tourist trade still remained at the Hotel. Young people left their families for jobs in other places, and Zoar slowly became a village of older descendants and younger outsiders who purchased the empty houses of residents who had died. This continued through the early 1980s.

In 1947 the Victorian addition to the Hotel was razed, as it was no longer

used and had not been built in the same sturdy manner as the original. In the 1950s the Hotel experienced a renaissance, not as a place to stay but as a place to eat. Postwar Sunday drivers made the Zoar Hotel a destination for hearty chicken dinners. Later Hotel proprietors turned its vast vaulted cellar into a Rathskeller bar complete with nightly entertainment. However, these owners could not make a go of it, and the Hotel closed in 1984 and remained vacant.

Townspeople celebrated the centennial of the Meeting House in 1953 with the performance of a play about Zoar history written by descendant Hilda Morhart. Unlike some of her generation, Hilda (1899–1978) listened to the stories told by the older residents and began writing them down. With the help of others, she turned these into the play, and later a book, *The Zoar Story*, written for Zoar's sesquicentennial in 1967. The book was illustrated with drawings by Zoar descendant Edna Bimeler Lueking.

The sesquicentennial in 1967 was a month-long celebration, and it included a reprise of the play, an art show, a music festival, and more. The success of the anniversary led to the formation of a new organization, the Zoar Community Association (ZCA), that same year. They decided to make their priority the restoration of the Zoar School, empty since 1953 and given back to the village. The ZCA leased it from the village in 1971, and restoration was completed in 1985. In 2001 the ZCA completed the restoration of the Zoar Town Hall.

The ZCA began a yearly celebration with some of the same features as the 150th anniversary. This Separatists Days, later called the Zoar Harvest Festival, has been celebrated for thirty years. Although the event has gone through changes, it still reminds visitors of its roots with the Last Load of Harvest procession, a reenactment of the bringing of the final wagonload of grain into town accompanied by the band, a service of thanksgiving, and a celebration. The ZCA also sponsors Christmas in Zoar and other events. It holds a Descendants Day reception each June and provides funds for many worthy village projects.

The Ohio Historical Society (successor to OSAHS) has gradually increased the number of buildings it operates and the extent of its interpretation of Zoar's history. In 1965 and again in 1967 the state's voters passed bond issues that allowed restoration to begin on the vacant Garden House, the recently acquired Bakery, and the sites of the Tin Shop, Wagon Shop, and Blacksmith Shop. After these buildings opened in 1970 and 1972 the Society employed costumed interpreters who were stationed in the buildings to tell about the

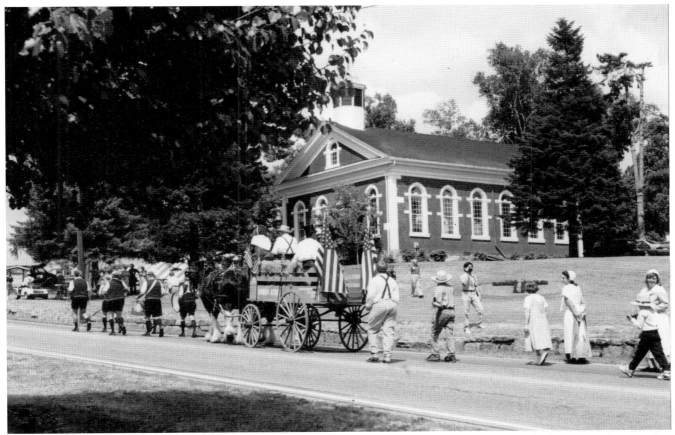

The Last Load of Harvest at the annual Harvest Festival reenacts a Zoar tradition. *Zoar Collection.*

site. Today visitors can take a combined guided tour and stationed tour that includes ten buildings.

The Zoar Store was acquired in 1970; restoration began soon after but was not completed until May 1980. Ticket sales and, later, the orientation video were moved here, and the Store sells reproductions of nineteenth-century objects, not typical "souvenirs." In 1990, with state capital funds, restoration began on the Dairy, behind the Store; work on the Kitchen-Magazine complex behind Number One House followed in 1992. These restorations, which richly illustrate Zoar's daily life, opened in April 1995. Other Zoar buildings owned by the State of Ohio have yet to be restored. The Sewing House, built 1830

The Garden House in 1967, under restoration by the State of Ohio and the Ohio Historical Society. *P365 Properties Collection.*

and purchased in 1965, now houses offices but is slated to be restored to illustrate Zoar's extensive textile industry. The Zoar Hotel, acquired in 1996, has undergone exterior restoration in preparation for becoming the site visitor center. It will include exhibits and artifacts showing Zoar history as well as classrooms, offices, and visitor amenities.

Since the mid-1970s private individuals have restored or rehabilitated their homes in the village, adding to its ambience for visitors. Zoar is unique among historic sites in Ohio, as it is an integral part of a real town with historic structures privately and publicly owned standing side by side. Many of the privately owned buildings house shops, restaurants, and bed-and-breakfast inns, which make a visit to Zoar complete.

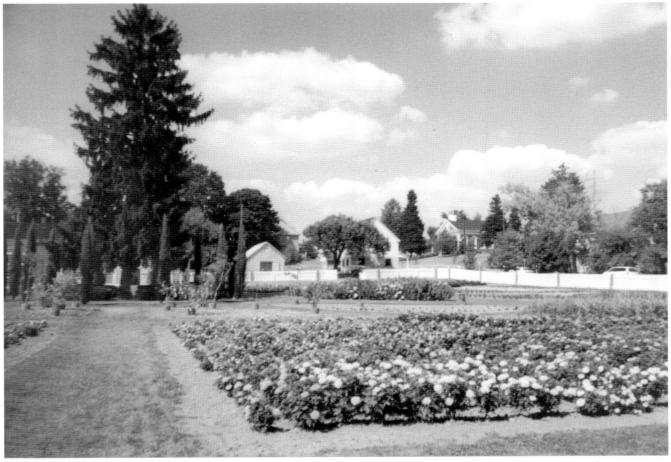

The Zoar Garden remains the centerpiece of the village. *Zoar Collection.*

Zoar's Legacy

Certainly important to its present-day appeal is the fact that Zoar is one of the longest-lived communal societies in the United States. But perhaps Zoar's greatest contribution is its clear illustration of two concepts held dear to all Americans: religious freedom and tolerance of differences.

Probably nowhere else in the world could a group of former prisoners and law breakers be allowed to come and set up their own religion within an economy contrary to the prevailing capitalistic system—and then be allowed to be successful within that system. No one marched or protested against them; in

Costumed staff and volunteer interpreters reenact life in nineteenth-century Zoar. *Photograph by Sally Yanice.*

fact, their neighbors looked them on fondly and possessively. The Separatists, despite their different lifestyle, were accepted by mainstream America and used the system to succeed and put their own particular German stamp on life in nineteenth-century America.

At the same time they also created their own German-flavored architecture, furniture, textiles, frakturs, and other artifacts that delighted the nineteenth-century narrators featured in this book as well as today's collectors and visitors. This distinctive stamp, this difference, this "most absolutely unique" quality, to quote again Geoffrey Christine of *Peterson's,* is what drew writers, photographers, and artists to Zoar and made the impressions expressed so eloquently and charmingly in this volume.

"Like Old World Pictures"

THE VILLAGE, ITS BUILDINGS, AND ITS AMBIENCE

On entering Zoar a visitor knew it was a special place. It was, and still is, unlike other rural Ohio villages. Not only was Zoar shaped by its location on the Tuscarawas River, but its German character and communal organization was evident everywhere—from its distinctive structures to the neatness and frugalness of its inhabitants. This aura attracted writers and photographers to Zoar who, in turn, left us with their impressions.

Just as I was at this spot, the shepherd drove a numerous flock of sheep over the bridge, and answered my questions in genuine Swabian German. His entire dress and equipments were quite in the German fashion: a shepherd's crook, a broad leather bandolier, ornamented with brass figures, a flat broad-brimmed hat, and a large grey coat; a costume very uncommon in America.

—Maximilian, Prince of Wied, June 24, 1834, *Travels in the Interior of North America* (1834)

The Zoarites raised large flocks of sheep, using the wool for clothing, coverlets, and blankets. The large barns in the distance are the granaries. The Hotel cupola can be seen in the upper left. *AV9 Collection.*

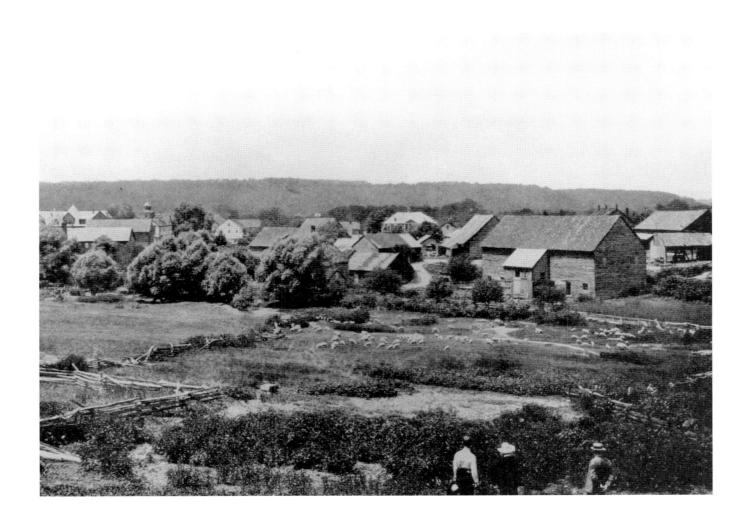

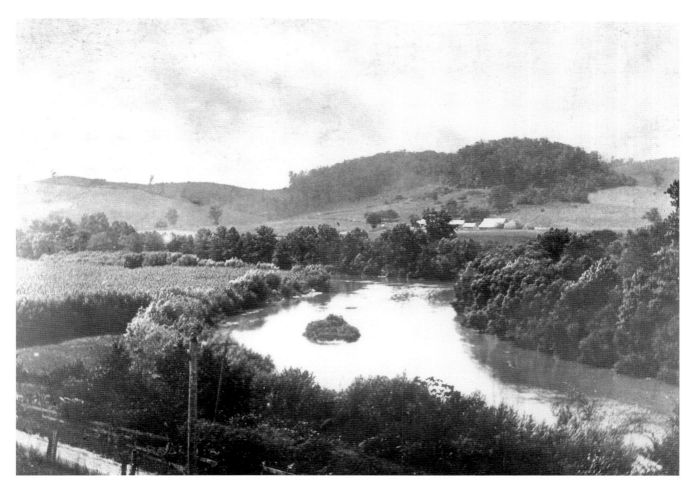

Moss-grown dykes, shaded by huge willows, protected the banks of the broad river, and here and there a shining little mill-race ran gayly through the meadows to some quaint, red-tiled mill, then plunging foaming over the stones, hurried on to overtake the old river sweeping steadily on to the south.

—Constance Fenimore Woolson, "The Happy Valley," *Harper's Monthly* (July 1870)

Zoar's location on the Tuscarawas River afforded it a fair amount of waterpower for its mills. This is the river east of the village in 1898. *P223 Baus Collection.*

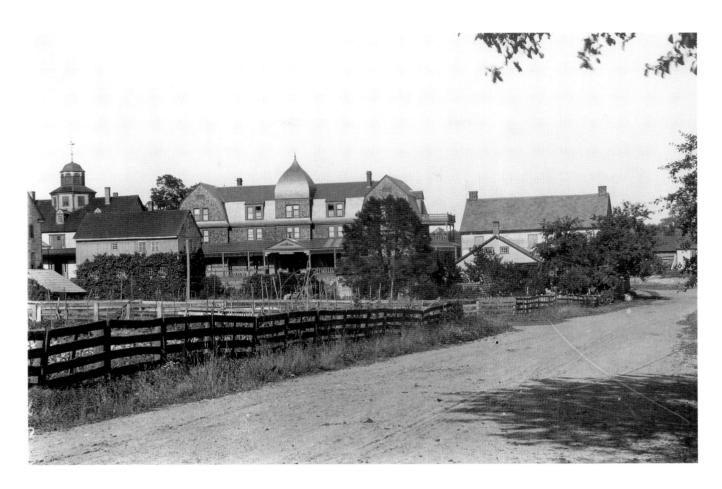

In passing from the canal to their public house, you cross a plain but substantial bridge, and enter upon a street that has the appearance of having been swept.
——Warren Jenkins, *Ohio Gazetteer* (1841)

Neatness was paramount in Zoar and certainly noticed by all of the visitors. The "public house" was the original Zoar Hotel (upper left), built in 1833. This photo shows the Hotel's 1892 addition (center left with the large dormers) and the rear of the Tailor Shop (left) and the doctor's home (right). *P365 Properties Collection.*

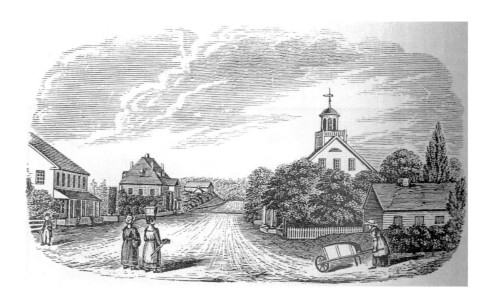

Everything is for use—little for show. The dwellings, twenty-five in number, are substantial and of comfortable proportions; many of them log, and nearly all unpainted. The barns are of huge dimensions, and with the rest are grouped without order, rearing their brown sides and red tiled roofs above the foliage of the fruit-trees, partially enveloping them. Turning from the village, the eye is refreshed by the verdure of the meadows that stretch away on either hand, where not even a stick or a chip is to be seen to mar the neatness and beauty of the green sward.
—Henry Howe, *Historical Collections of Ohio* (1847)

This woodcut by Henry Howe is the first known depiction of Zoar. It shows the Store and Number One House to the left and the Hotel cupola and Wagon Shop to the right. From Howe, *Historical Collections of Ohio* (1847).

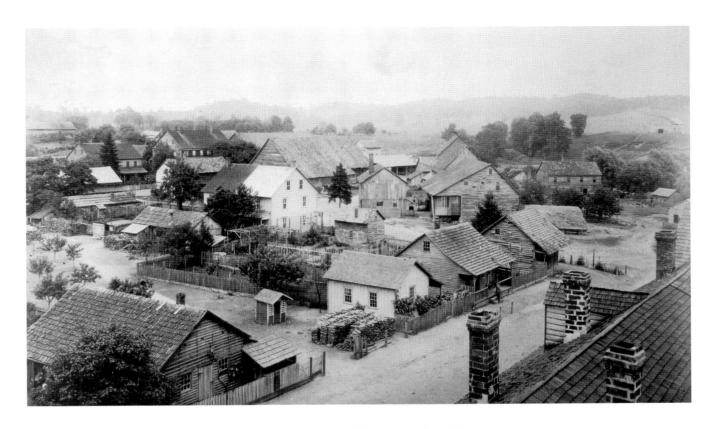

The architecture was quaint, and reminded one of Old World pictures. The red-tiled roofs projected over the street and great cross beams filled in with mortar, formed the walls; little dormer windows were perched here and there with no attempt at regularity.

—Constance Fenimore Woolson, "The Happy Valley,"
Harper's Monthly (July 1870)

This photograph, taken from the Hotel cupola in 1888, shows many outbuildings and barns. The granary (center upper left), the Tannery complex (center upper right), the Hotel laundry (white building, center), and the Hackle House (for flax processing) next to it are all now gone. The tiny building to the rear and left of the Hackle House was the apple "snitz" drying kiln. *P365 Properties Collection.*

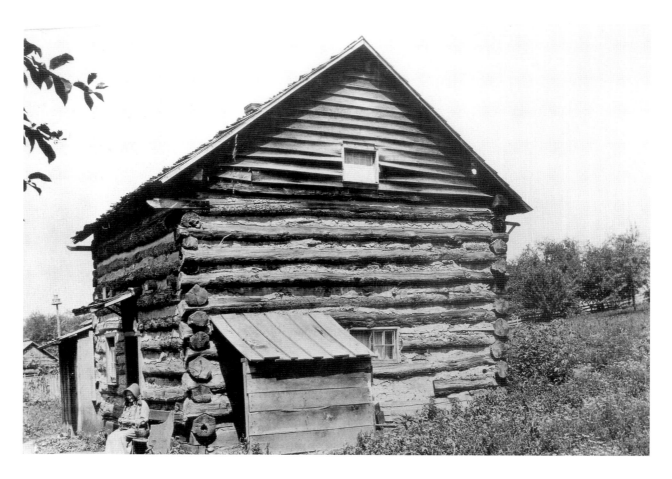

He [Bimeler] invited us into his Garden which was decked with flowers and shrubs [sic] of very different kinds and some few trees[.] On the North side is his bee house containing more than 40 hives[.] These he does not kill to get the honey, but places boxes on them not ruining it in that way. His house is nothing more than any of the rest and his dress was nothing superior[.] He is also their only physician.

—Moses Quinby, October 13, 1831, "Diary"

Bimeler's home, which still stands today, was one of the first cabins built in 1817 and additionally served as the community's first church. Quinby, a traveler on the Ohio & Erie Canal, was an expert beekeeper. *P223 Baus Collection.*

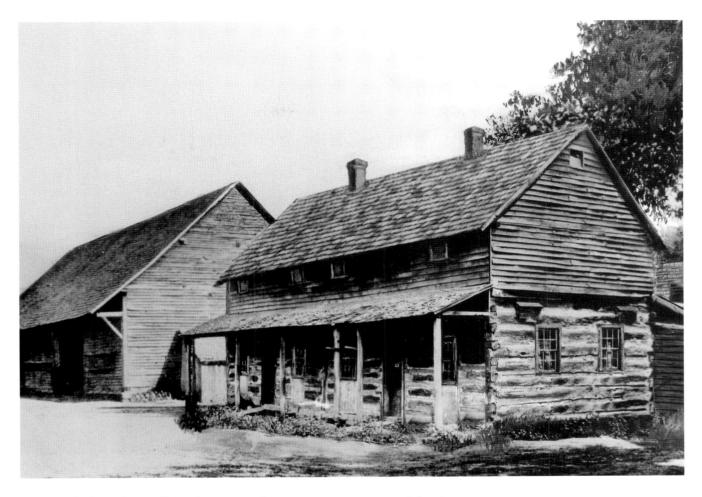

Some of the log cabins still stood in part—if not entire—mementoes of the pioneer life of the Society.

—E. O. Randall, *History of the Zoar Society* (1899)

This log cabin was the Society's church before 1853. It additionally served as the Girls' Dormitory before the practice of separating children from their parents ended in 1860. *Zoar Collection.*

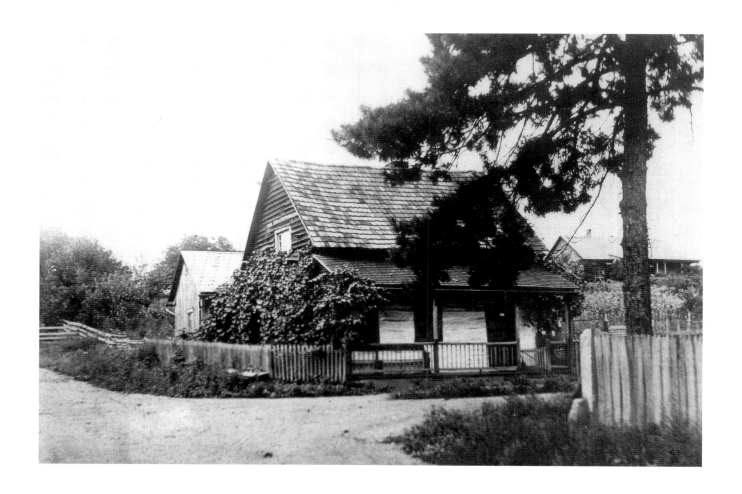

The other picturesque characteristic of the village were [sic] the old, red, heavy, trough-shaped tile roofs that covered many of the buildings. At one time the manufacture of these tiles was an industry of the Society, but long since the market for these obsolete goods ceased.

—E. O. Randall, *History of the Zoar Society* (1899)

Tile roofs were common in the Separatists' German homeland and graced most of the roofs in early Zoar. By reports, a tornado in the 1820s caused many to be dislodged. Tile roofs can still be seen on several Zoar structures, including this one, the 1817 Zeeb cabin, on the corner of Fourth and Park Streets, today a bed-and-breakfast inn. *P223 Baus Collection.*

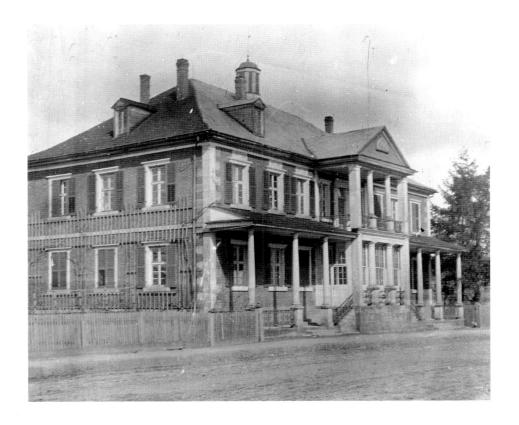

It is a wide-spreading brick mansion with a broadside of white curtained windows, an enclosed glass porch, iron railings and gilded eaves, a building so stately among the surrounding cottages that is has gained from outsiders the name of the King's house, although the good man whose grave remains unmarked, was according to the Separatists' custom, not a King, but a father to his people.

—Pipsey Potts, "A Queer, Quaint People, Part 1,"
Arthur's Home Magazine (May 1882)

Number One House was originally built in 1835 to house the community's elderly citizens. This was an unsuccessful experiment, however, and it then became home to two of Zoar's three Trustees. Grapes for wine making were grown on the trellises at the south end of the building. The houses in Zoar were numbered for identification, as usually more than one family shared a home. *Zoar Collection.*

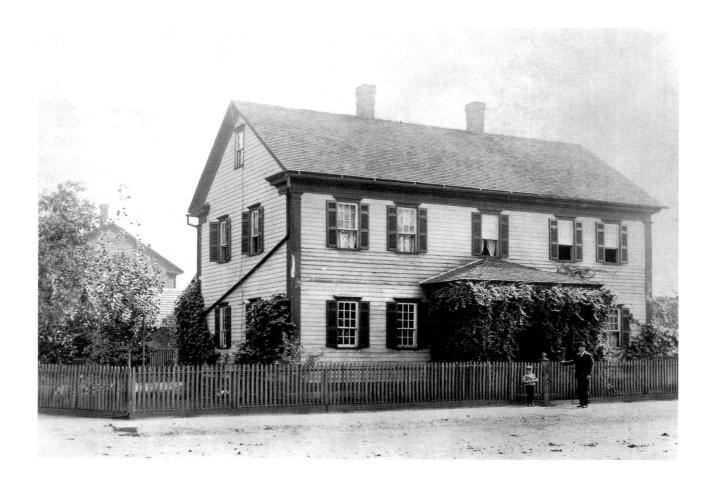

Everything has an air of neatness about it which cannot be found in any other village in the State. No ruined gate, nor rotten fence, nor tottering shanty is to be seen. The women seem as if perpetually scrubbing, and in every house we passed we heard the mop in motion.—Floors, porches, benches, pavements, trees, stables, children and animals, all things, in short, undergo the same daily manipulation as if the least speck of dirt was the mortal enemy of every house-wife.
— "The Separatist Society," *Ohio Statesman* (September 18, 1859)

Picket fences around each home kept out roaming chickens and other animals. This house was built about 1836, and it still stands. *P223 Baus Collection.*

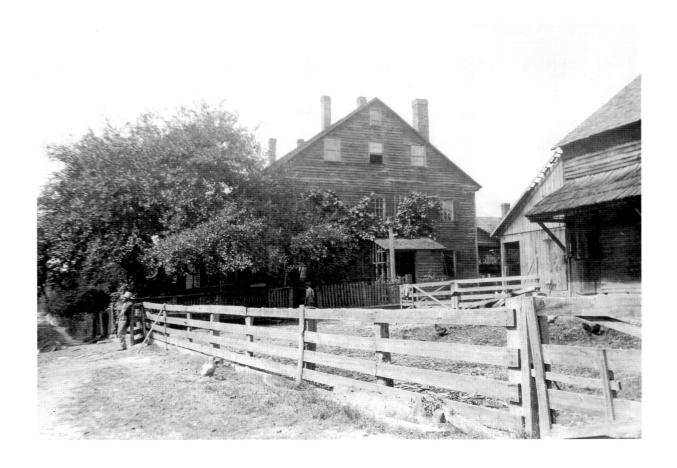

The Society was driven to the employment of imported help. A field near the ceme-
tery was being plowed by four teams, driven by as many plowmen. I accosted them as
Zoarites, only to learn all were "hired help" and foreign to the Society. Some fifty men
were on the pay roll of the Society at the time of my visit, all of course non-members.
—E. O. Randall, History of the Zoar Society *(1899)*

Male laborers were always at a premium in Zoar, dating back to the group's
arrival with two-thirds as many women as men. This house, the Bauer (or
Farmer) House, was a dormitory for these outsider laborers. Society children
were warned to stay away from these rough "hands," but they still managed to
infiltrate the community with their worldly songs, customs, and language. *P223*
Baus Collection.

Once a year the members of the society met in the Town Hall, situated in a small frame building erected for that purpose, and in the little belfry of which hung the bell that called the people to work in the morning and sounded the dinner and quitting hour. In this little hall the members would gather, hear reports from their officers, consider their questions, discuss their interests and hold their elections.
—E. O. Randall, *History of the Zoar Society* (1899)

The community incorporated as a village in 1884, and the Town Hall was built to house the governmental offices. Previously, elections and meetings were held in the Meeting House. The fire engine was housed here, and the town band held concerts on the flat porch roof. Today the Zoar Community Association has restored the building as a community center and museum. *P223 Baus Collection.*

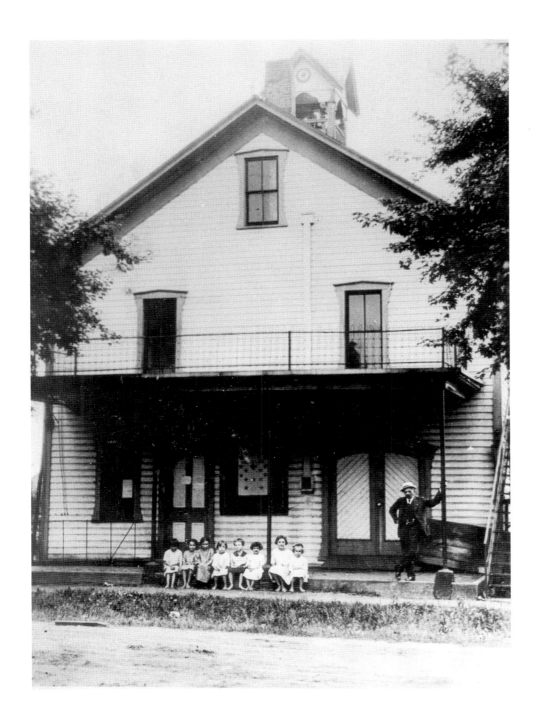

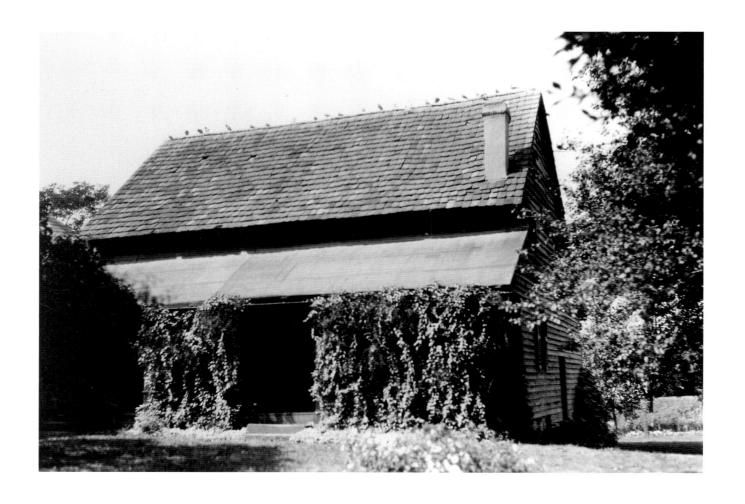

Tea, coffee, sugar and other "groceries" are served out to all householders once a week.
—Charles Nordhoff, *Communistic Societies of the United States* (1875)

Zoar, like most communal societies, operated without money. To allow members to obtain needed supplies, the Zoar Society maintained the Magazine, or storehouse, where members picked up these goods. This photograph shows the Magazine in 1930 after it had become a private residence. Today it is restored and open to the public. *P223 Baus Collection.*

"Their Morality Is Without a Flaw"

ZOAR RESIDENTS AND THEIR LIFESTYLE

"To work for the good of all" was the Zoar credo. The community was very close, observing a strict equality lest anyone develop jealousies, and communalism on earth was seen as a way to prepare one for the equality of Heaven. Individualism was put aside for the good of the community.

. . . I asked, "What advantages do you enjoy over common society by reason of your Communism?" I got the answer that made me think their life might be richer and nobler than [it] appears. . . . "The advantages are many and great. All distinctions of the rich and poor are abolished. The members have no care except for their own spiritual culture. Communism provides for the sick, the weak, the unfortunate, all alike, which makes their life comparatively easy and pleasant. . . . The burden which would be ruinous to one is easily borne among the many. . . . Finally, a Community is the best place in which to get rid of selfishness, willfulness and bad habits and vices generally; for we are subject to the constant surveillance and reproof of others which, rightly taken, will go far toward preparing us for the large Community above."

—William Alfred Hinds, *American Communities* (1878)

Multigenerational family units were the norm in Zoar; eventually almost every community member was related to another. This is three generations of the Kappel family, the community's weavers, ca. 1890. *AV9 Collection.*

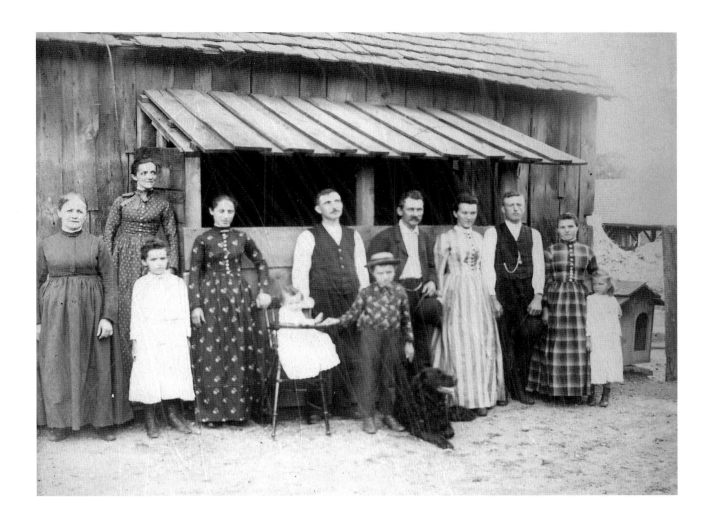

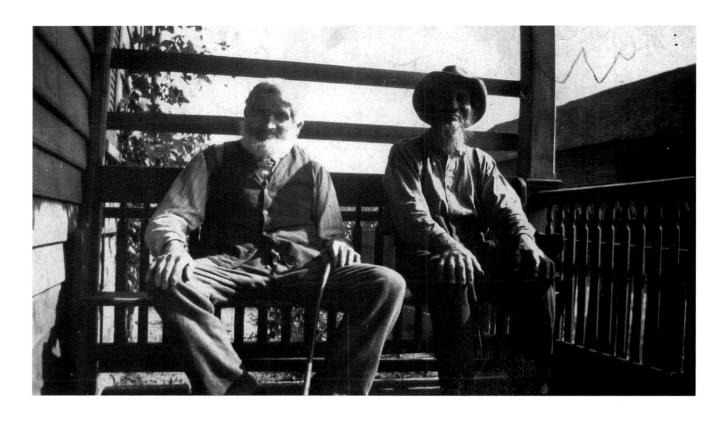

In the workshop, they sing and laugh and the old separatists, who officiate there as overseers, are the jolliest.
 —Karl Knortz, *Aus der Mappe eines Deutsch-Amerikaners* (1893)

Many observers of Zoar mentioned that no member seemed to work hard and that the Trustees, like Christian Ruof (left, pictured here after the Dissolution), worked right alongside the members. *Zoar Collection.*

The present leader, Jacob Ackermann, would be taken by a stranger as one of the common members. There is nothing in his appearance betokening superiority or any special ability; and yet he is greatly respected by all, and exercises a controlling influence in the Society. Although seventy-four years of age he still has the chief superintendence of both the lower and higher interests of the Community, and does more labor with his hands besides than many a younger man. In conversation with him you are impressed with his simplicity and sincerity. You feel that here is a man who can be safely trusted. He wins your full confidence at once. This, I take it, is the secret of his power as a leader. Then, too, he impresses you as a sympathetic, kind-hearted man—one who would willingly share your burden.
—William Alfred Hinds, *American Communities* (1878)

Ackermann, an early member of the Society, became the community's leader after Joseph Bimeler's death in 1853. Although skilled in many ways, he did not have Bimeler's spiritual leadership, and church sermons and services became rote, a major reason for the Society's eventual demise. Ackermann died in 1889, having been a Trustee for fifty-nine years. *P365 Properties Collection.*

They have always been non-combatants, and their constitution declares: "We can-not serve the State as soldiers, because a Christian cannot murder his enemy, much less his friend." At the time of the late war, they paid the Government a heavy sum for immunity from conscription, yet a number of the young men, disregarding this, and not heeding the protests and appeals of the elders, went off and enlisted.
—Robert Shackleton, "In Quaint Old Zoar,"
Godey's Magazine (November 1896)

Many of the twelve surviving Civil War veterans returned to the community, with several becoming members of the Society while others worked for wages. The Society opposed slavery and supported the Union cause. Zoar-made blankets and other products were sold to the Union Army. *P365 Properties Collection.*

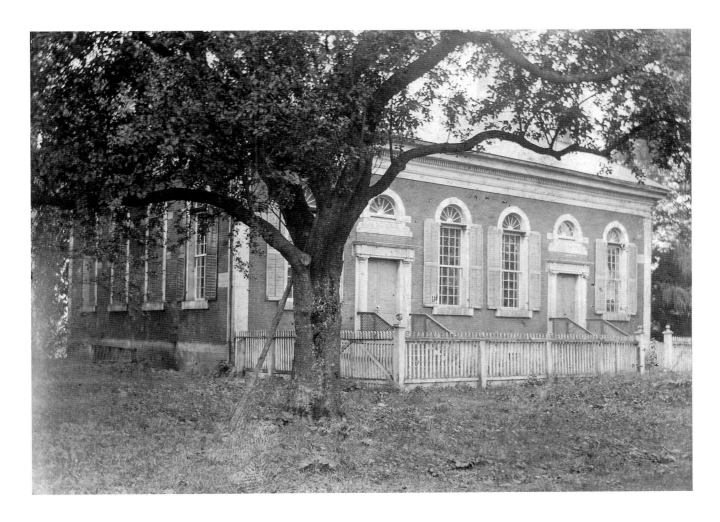

The church has two doors, one for women, the other for men, and the sexes sit on different sides of the house.
 —Charles Nordhoff, *Communistic Societies of the United States* (1875)

The sexes were separated during worship, men entering on the right and women on the left. This was the second Meeting House (the Separatists were careful not to call it a "church"), and, like Number One House, it was designed by leader Joseph Bimeler. However, it was not completed before his death in 1853, and he never presided here. *P365 Properties Collection.*

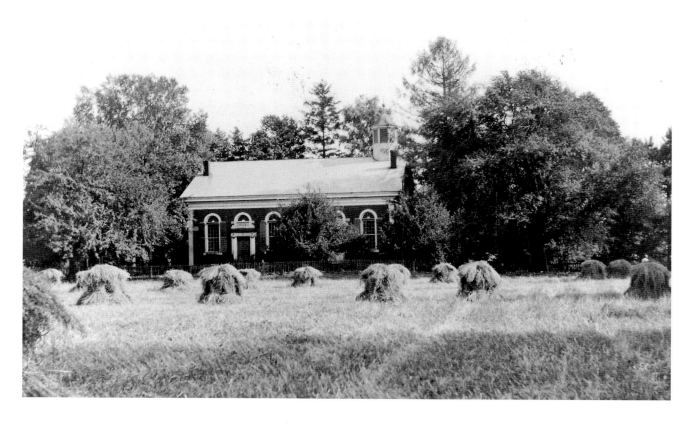

*On Sunday we went to the little church and watched the long file of worshipers
march gravely in, the men at one door, the women at another, and seat themselves
in solid rows on the blue benches, when the service began with a hymn, followed
by a long sermon. . . . The singers were accompanied by a band of ten musicians
seated on a platform near the pulpit, who elicited very sweet music from a collec-
tion of quaint wooden pipes, flageolets, flutes and violins, whose patterns came
from the old country half a century before, and, like every thing else in the Happy
Valley, remained unchanged.*

—Constance Fenimore Woolson, "The Happy Valley,"
Harper's Monthly Magazine (July 1870)

The hymns, which used Lutheran chorales as the melodies, were accompa-
nied by music. *Cleveland Public Library.*

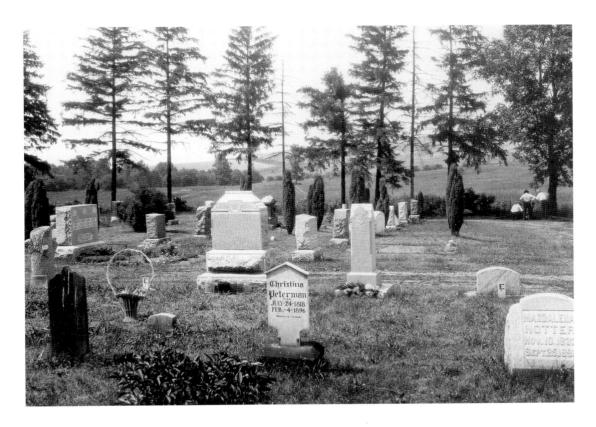

The path to the cemetery of the separatists, which is situated on a hill close to the bank of the Tuscarawas river, leads through a narrow well cultivated avenue of firs. The evergreen fir seems to be the favorite tree of our colonists. Such a tree stood on nearly every grave. Only since the year 1860 is it permitted to place stones with inscriptions on them.

—Karl Knortz, *Aus der Mappe eines Deutsch-Amerikaners* (1893)

The Separatists believed that all were equal in death as well as life, and because Christ's return was imminent it mattered not where one was buried. Funeral customs were also plain, with a procession to the grave site being the only ceremony. Community leaders often gave a summation of the deceased's life at the next Sunday's church service. As Knortz observes, grave markers were only used after about 1860. Christina Peterman, whose grave is shown in the foreground, was the first child born in Zoar. *P223 Baus Collection.*

Everything was so unlike any service we had ever attended that for a moment we stood like gawkies, looking to the right and to the left. . . . We felt like intruders, until an elderly lady snapped her head a sudden jerk toward a vacant seat. It was in front and near the pulpit. The service consisted of reading and singing, all in the German tongue, accompanied by sweet music from a splendid pipe organ. The music was like a chant, a rising and falling of sweet sounds, in which the many voices mingled in perfect harmony-chorals old as Martin Luther. There were no prayers. They have no baptisms nor sacraments. The sermon which was read did not arouse interest nor a sign of enthusiasm. The afternoon exercises— when they have any second service—consists of catechising from a German work for biblical instruction. The house was plain inside, and carpeted with dark, home-made blue and black rag carpet, the seats uncushioned, and tallow candles are used instead of chandeliers at night.

—Pipsey Potts, "A Queer, Quaint People, Part III,"
Arthur's Home Magazine (July 1882)

This photo was taken after the Dissolution, when the church interior was reconfigured, with the pulpit and seats now facing the narrow end of the church rather than the longer side. The organ, installed in 1873, replaced the musical instruments mentioned earlier by Woolson, and it is still used today. *P223 Baus Collection.*

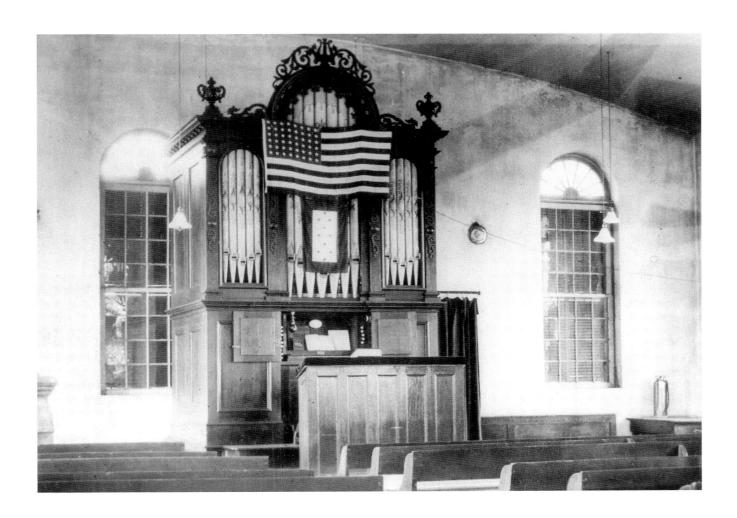

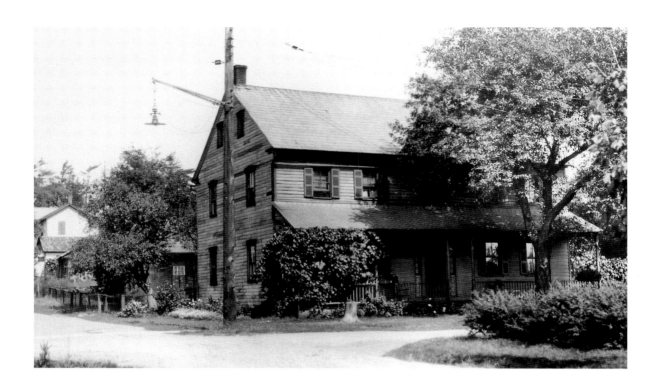

From the time of [the children's] entry they are under the supervision of women, whose duty includes looking after their clothing and keeping them clean. Those children who do not yet have the necessary dexterity are . . . dressed, washed and combed by these women. All these children, separated by sex, however, eat together in several houses in the neighborhood of the public school where several of the already mentioned cooks prepare for them meals that are good, palatable, and appropriate to their age. These women see to it that the children behave decently during the meals, while they perform the main job of serving and waiting on them.

—P. F. D., "Harmony Builds the House . . ." (1832)

This photo is of the Boys' Dormitory, or nursery, which still stands. The girls lived across the street in the upper story of the church. In addition to caring for the children so that their mothers could do other work in the community, the matrons trained the children to do handwork. Their regime was reportedly often harsh, with a certain amount of work having to be done before bedtime. The dormitory system ended in 1860. *P365 Properties Collection.*

The community consumes three thousand dollars' worth of beer alone in a year, to say nothing of cider; and every household has a private stock of wine, made from everything conceivable—blackberries, currants, grapes and even elder-flowers. An insatiable thirst is the strongest sentiment in Zoar.
　　　—Alexander Gunn, June 4, 1892, *Hermitage-Zoar Note-Book* (1902)

This was the opinion of Gunn, who himself added to the considerable amount of drinking done in Zoar during the 1890s. A wealthy outsider who periodically lived among the Separatists in an original log cabin, Gunn counted several Trustees among his friends and held nightly soirees and threw lavish parties, all of which contributed to the eventual Dissolution. Beer was stored in this cellar beneath the Brewery. *P223 Baus Collection.*

The beer quaffed at meals is of a kind that might tempt the most rigid anchorite to break his vows. Nothing whatever enters into its composition save barley, malt, hops and pure spring-water. Like the cider manufactured and consumed here in great quantities, and the magnificent beeves slaughtered daily, it is kept in a common stock, from which each family is supplied every morning, according to its needs.
—Geoffrey Williston Christine, "Zoar and the Zoarites," *Peterson's Magazine* (January 1889)

Many of today's Americans are surprised that the religious Separatists drank beer, hard cider, and wine. These were German customs, and temperance was not part of their religious creed. Beer was considered "liquid bread," and making cider and wine were ways of preserving the produce they grew. But drinking to excess was considered a sin, and it did not become a problem until the last days of the Society. *P223 Baus Collection.*

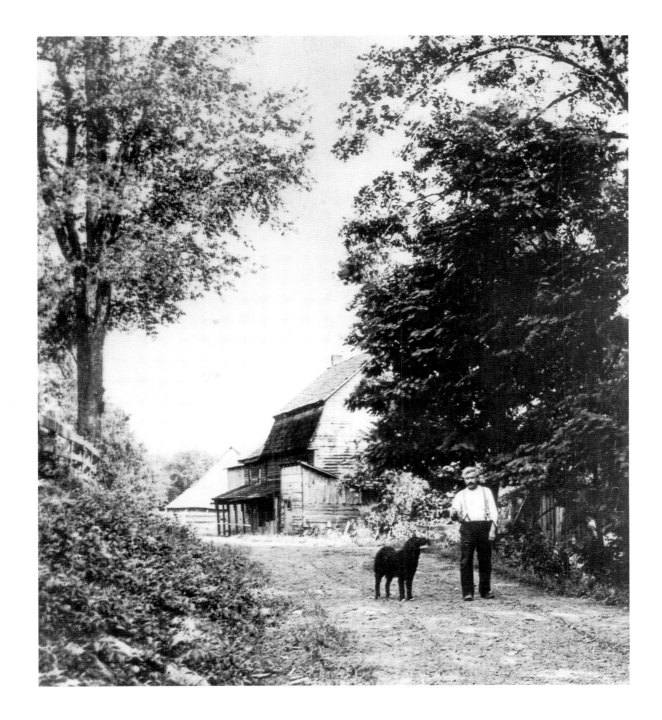

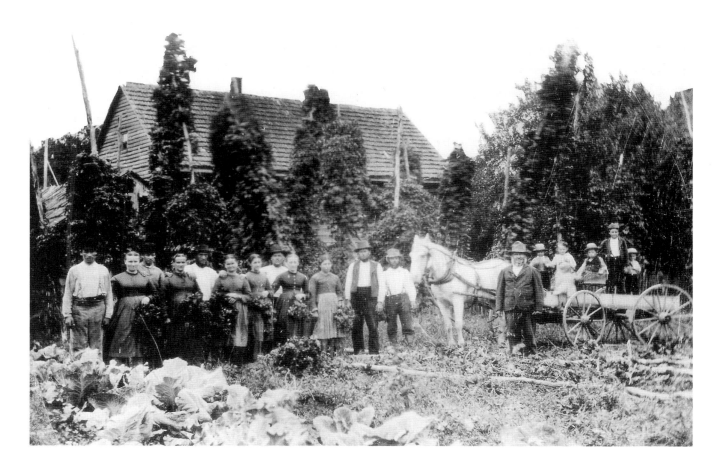

We rode home by the way of the extensive hop garden, luxuriant and fragrant, and more graceful and beautiful than all the vineyards in the world.
—[Sophia Dana Ripley], "A Western Community,"
New Yorker (July 17, 1841)

Hops were not only added to the beer brewed in Zoar but were an essential ingredient in their recipe for liquid yeast used in the Bakery. Hops are climbing vines that are trained to grow on poles. Hops pulling, or harvesting, was a social event each September. *P365 Properties Collection.*

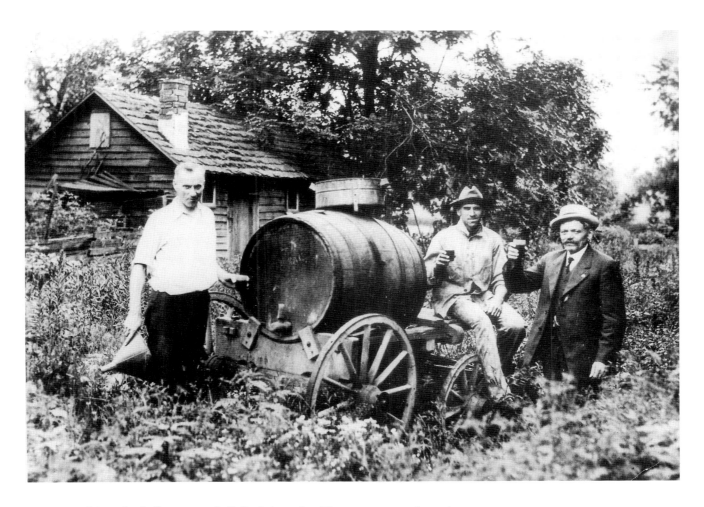

At nine and four the bell rings, and all flock for cider. There is not anywhere the spectacle of people hired to work and then made unfit by entertainment given by the employers, except in Zoar.
—Alexander Gunn, September 16, 1897, *Hermitage-Zoar Note-Book* (1902)

With the hard work of farming, the Zoarites needed the energy provided by midmorning and midafternoon breaks, two of the usual five meals a day. Sometimes light meals, called *brod-esse*, or "bread-meal," were taken out to the workers in the fields by this special cider wagon and included bread, apple butter, cheese, and hard cider. *AV9 Collection.*

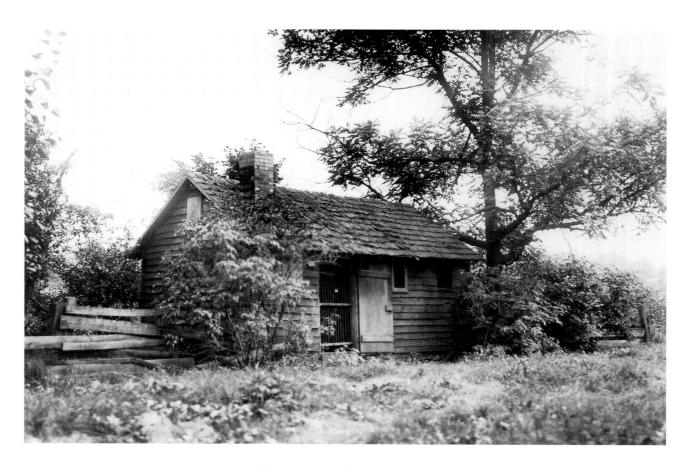

Near by was a stunted, one-story, sullen, ominous[-]looking structure with small iron-grated windows and a heavy double plank door. It was the Zoar Bastille; they called it the "calaboose." I inquired with much surprise as to the necessity for this penal institution in so moral and sober a community, and was informed with a smile on the part of my respondent, that it was built solely for the benefit of visitors to the village. It came with the incorporation of the town and the town marshal.

—E. O. Randall, *History of the Zoar Society* (1899)

The calaboose became a home for inebriated guests and wandering tramps (the Society became well known among hoboes). The Separatists themselves never had occasion to use the jail, as none was ever accused of a crime. *P223 Baus Collection.*

In their garden a martin-house is full of clamorous birds, whirling always about and making a hard fight to keep the sparrows from crowding them out of the house.
—Alexander Gunn, May 20, 1896, *Hermitage-Zoar Note-Book* (1902)

The Separatists kept purple martin houses all over the village. The birds kept the insect population under control. *P223 Baus Collection.*

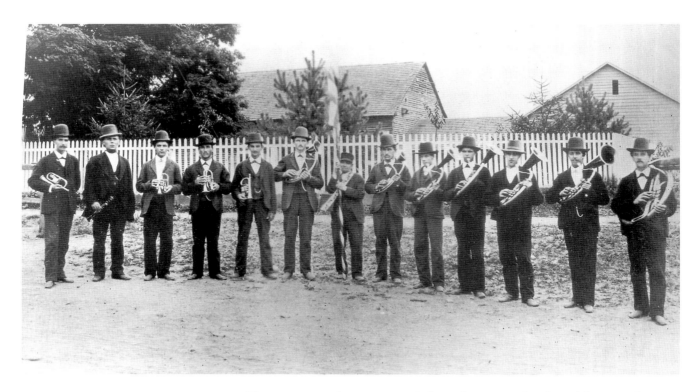

The young men have organized themselves into a band, and have good instruments, and this entertainment, twice a week, in the street, between the hotel and the store, is looked forward to with interest. During summer evenings they meet oftener and sit in the centre of the great garden and play until the bell rings for the hour of retirement.

—Pipsey Potts, "A Queer, Quaint People, Part II," *Arthur's Home Magazine* (June 1882)

Music, both religious and secular, was a part of the lives of the Separatists. Because they had no outside instructors, one member, Albert Beuter, had to leave the Society in order to pursue a musical career. He later became a noted teacher and composer. *P365 Properties Collection.*

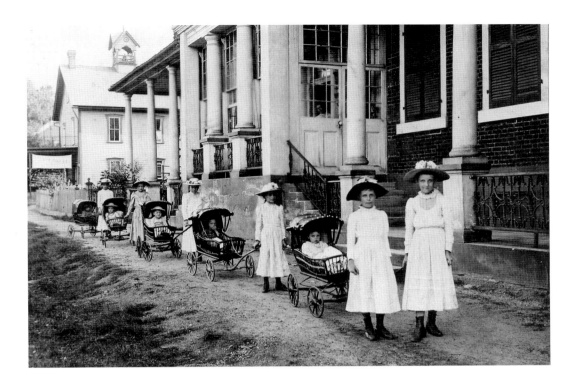

I encounter a most singular procession, the like of which I have never seen in any other part of the world. Some fifteen or twenty girls, ranging in age from ten to thirteen years, are walking in single file, each drawing behind her a younger brother or sister in a old-fashioned baby-coach from which projects a tongue even longer than that of the most inveterate gossip. Strict equality is observed by the Zoarites in everything. Just as they hold all property in common, so they participate in all pleasures and duties. Thus, even the babies of the Society are aired simultaneously in a procession of "sweetness long drawn out."

—Geoffrey Williston Christine, "Zoar and the Zoarites,"
Peterson's Magazine (January 1889)

The secret to success in a communal society is that no one feels different from his or her neighbor, thereby reducing causes for jealousy. In this way the Separatists dressed alike, had identical baby carriages, and gave their children airings at the same time. To be different was to feel left out, apart from the community. *P365 Properties Collection.*

All members of the Society are dressed in blue fabric of their own manufacture, the peculiarities of the male attire being an abbreviated coat of an unfashionable cut. The dresses of the females are of the same material and color, variegated by a white apron and a spotless triangular handkerchief about the neck, the points of which meet the apron strings before and behind. This primitive and somewhat picturesque costume is completed by an immense straw hat, (bound by a ribbon of the never failing blue,) and a plentiful lack of crinoline—an institution of which the Zoar belles are entirely ignorant, or, if known to them, is totally ignored as a new fanggled [sic] innovation upon the classic simplicity of their sex.

—"The Separatist Society," *Ohio Statesman*
(September 18, 1859)

"Zoar blue" was a dye made from woad, a yellow-flowered weed, which was less expensive than indigo. Unfortunately, we have no photographs of early Zoar dress, nor do we have any examples. It is said that clothing was worn until it wore out, and thereafter it was made into rag rugs. Like everything else in Zoar, nothing was wasted. The dresses seen here in this photo dated 1888 show the influence of outside fashion; however, the enormous hats mentioned by many visitors are still being worn by the women workers. *P365 Properties Collection.*

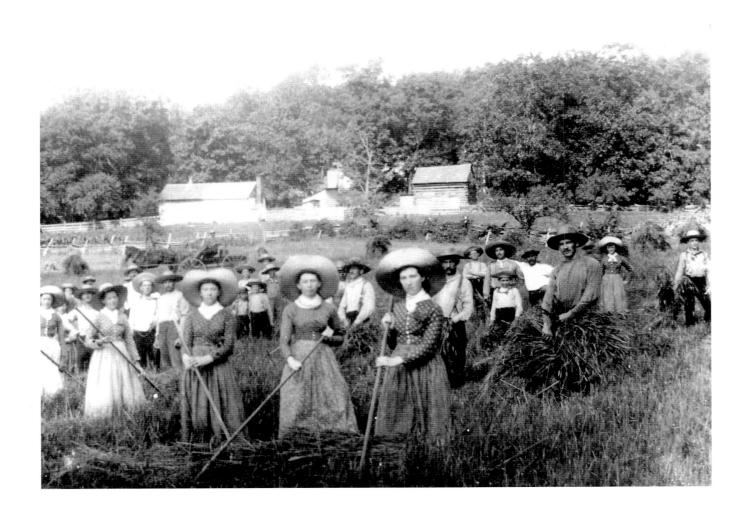

"Trading Center for the Region"

TRANSPORTATION AND INDUSTRY IN ZOAR

Visitors, both then and now, are surprised at how quickly the Zoarites became industrialized. Their location on the Ohio & Erie Canal, as well as their enthusiastic participation in its building, were instrumental in their success as a community. Unlike the railroad, the canal allowed the Separatists to participate in the business of the world from a safe distance. But the railroad, especially after it came right into town in 1882, brought the world to Zoar.

The inhabitants of Happy Valley, ignorant of the value of money, and living in the simplest manner, are yet a rich community, owning to their industrious habits and systematic labor. Their domain consists of over ten thousand acres of highly cultivated land, a coal mine, and a bed of iron ore; they have several large mills and factories, as their invariable rule is to manufacture every thing they use.

—Constance Fenimore Woolson, "The Happy Valley,"
Harper's Monthly Magazine (July 1870)

Woolson exaggerates somewhat in her estimation of the amount of land the Separatists owned. They never owned more than 8,724 acres, and in 1870 they owned about 7,187 acres, which remained at the Dissolution in 1898. This photo, dated 1896, shows the extent of the village, with the enormous cow barn on the left and the new Hotel addition center right. *P365 Properties Collection.*

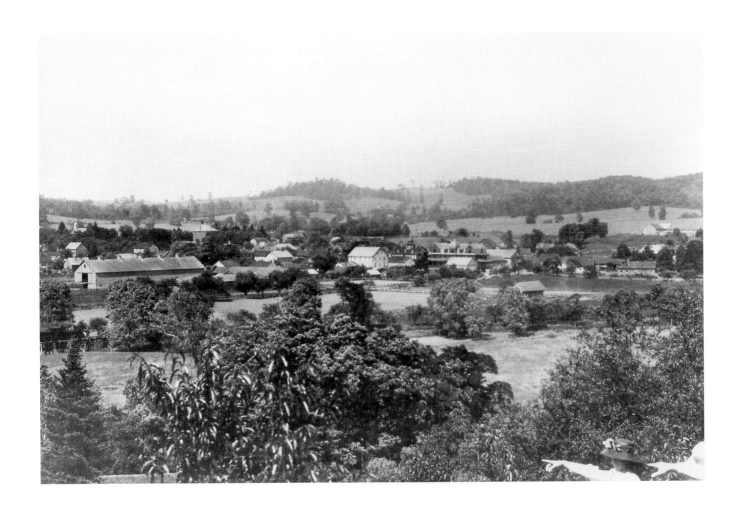

The Ohio canal runs through the river valley and lies like a silver cord winding through the rich bottom lands. The boats glide quietly by between grassy banks, and the boatman's horn sends an echoing song that reverberates among the Tuscarawas hill tops.

—Pipsey Potts, "A Queer, Quaint People, Part II,"
Arthur's Home Magazine (June 1882)

The slow speed of the canal allowed the Separatists access to the world yet kept it at a safe distance. Use of the canal for shipping allowed them to develop their iron and milling industries. *P223 Baus Collection.*

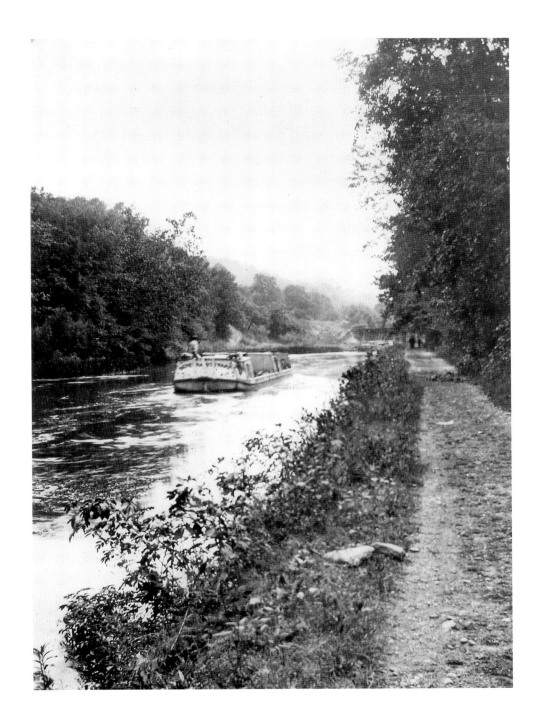

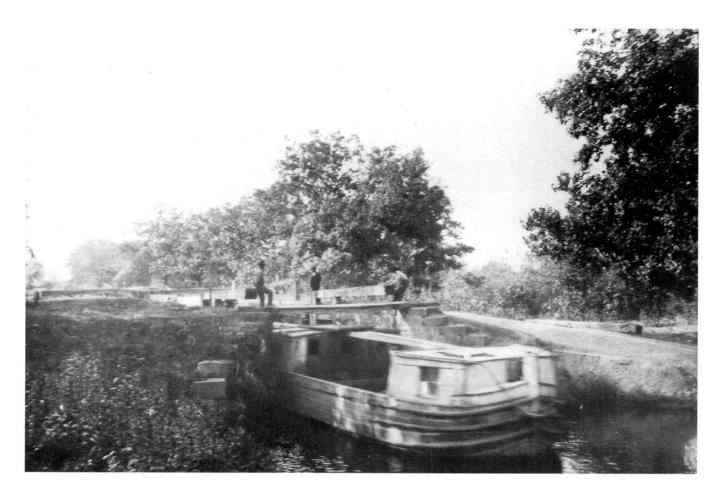

They contracted to dig the Ohio canal throughout the extent of their territory, by which they not only acquired 21,000 dollars ready money, but also made a considerable sum by furnishing all the neighbouring contractors with bread.
—"The Colony of Zoar," Penny Magazine *(October 26, 1837)*

The Separatists lobbied the State of Ohio in the mid-1820s to have the canal traverse seven miles of their land. This payment allowed them to pay off their land debt. During construction of the canal everyone worked. Legend says the women carried dirt from the excavation in baskets on their heads or in their aprons. *P223 Baus Collection.*

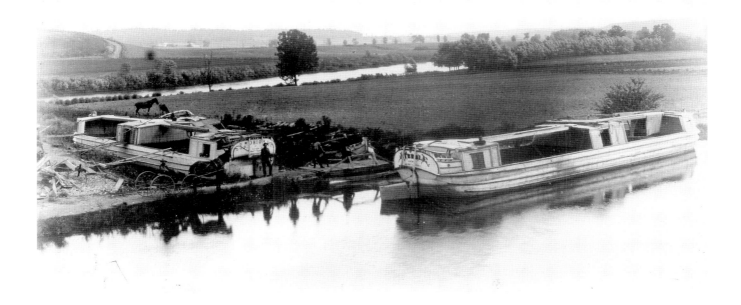

The value of their land also suddenly increased because of it [the canal] by more than half. This is because now, by means of this canal, they are able to ship their surplus products and manufactured articles, at will and without great expense and loss of time to wherever they expect the most favorable market. The warehouse at Zoar has actually become the trading center for the whole region.

—P. F. D., "Harmony Builds the House . . ." (1832)

The Society owned three different canal boats: the *Industry*, the *Economy*, and the *Friendship*. Much of the time they hired outsiders to captain them, but member Johannes Petermann (1819–1872) was also a canal boat captain. The basin seen here, north of the village, was where boats turned around or were repaired. *P365 Properties Collection.*

A railroad is in progress of building that will unite them to the world. Ere long its throbbing pulses will be felt at Zoar. The glitter of the engine will cast its shine upon the great windows of the church on the hill, and the rushing trains will jar the peaceful graves of the dead, and people will walk the wide street in the little village and curl their lips "half in pity, half in scorn," over the cumbrous tiled roofs and old fashions and sacred customs of this united colony which was once a poor handful of strange seed sown in peril and with misgivings and sorrow in the New World across the vast Atlantic.

The Community gave generously to secure the location of the railroad near them. The changes that follow its advent will be marked in more ways than one.

—Pipsey Potts, "A Queer, Quaint People, Part III,"
Arthur's Home Magazine (July 1882)

The Wheeling & Lake Erie, like many railroads in northeastern Ohio, was built along the Ohio & Erie Canal. The railroads ultimately supplanted the canal, although the Zoarites continued to use the canal for transporting heavy cargo. Potts's observations about how the railroad would change Zoar were correct: it brought the outside world right into the village, mainly in the form of increased visitation by tourists. *P223 Baus Collection.*

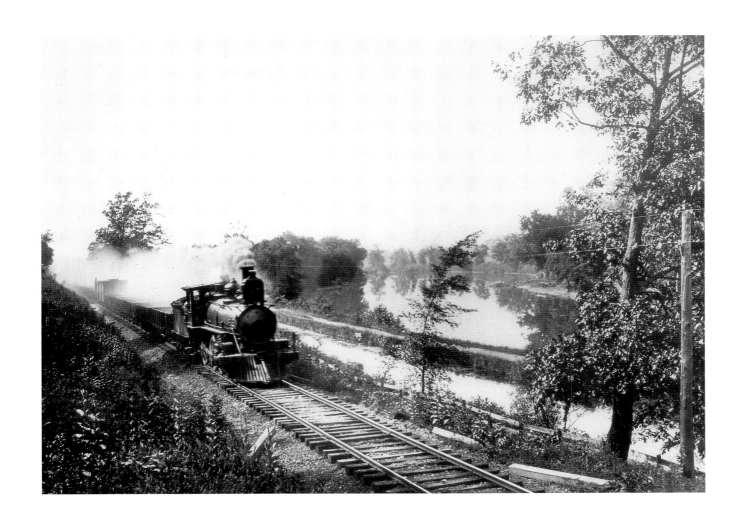

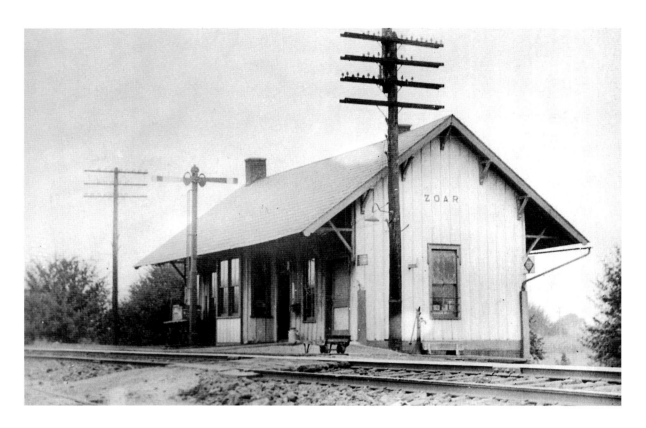

Zoar is about ninetyfour [sic] miles from Cleveland, and one hundred and six miles from Pittsburgh. It is reached by the Cleveland & Pittsburgh Railroad—a tie that binds it to both cities, though the station is some three miles distant from the village. The Wheeling & Lake Erie Railroad runs directly to the town and connects with Wheeling and Toledo.

—Geoffrey Williston Christine, "Zoar and the Zoarites,"
Peterson's Magazine (January 1889)

The Cleveland & Pittsburgh Railroad came to Zoar Station (later Zoarville), two miles from the village, in the mid-1850s. The Separatists built a store at the depot and began to send their products to market by rail. The Wheeling & Lake Erie arrived in 1882, with this station right in town. Jacob Sturm, a Society member, was the W&LE stationmaster. Even though paid by the railroad, he turned over his salary to the Society. *P365 Properties Collection.*

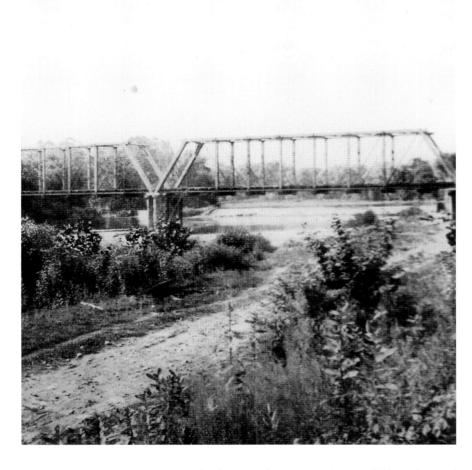

I watch the men put up the new bridge over the river; with incredible agility and strength they climb to the top of the scaffolding, and carelessly work at that dizzy height.

 —Alexander Gunn, April 26, 1898, *Hermitage-Zoar Note-Book* (1902)

This is the Wheeling & Lake Erie Railroad bridge, which was replaced in the twentieth century, though its abutments still remain. The Separatists' river walk can be seen in the foreground. *P365 Properties Collection.*

On the Tuscarawas River the Society of Separatists of Zoar also owns a saw mill, which is hard at work almost day and night unless prevented to do so by too high a water level, but in spite of all this activity, it is barely able to fill their own needs. The reason is that the people have started to build roomier, more pleasing and healthier dwellings, instead of the early and confined block [log] houses.
—P. F. D., "Harmony Builds the House . . ." (1832)

After the Society became debt free, building construction began in earnest. Many of the signature structures in Zoar (Number One House, Hotel, Store, Boys' Dormitory) were built during the early 1830s. Much of the Society's land was virgin forest, so lumber was plentiful. *AV9 Collection.*

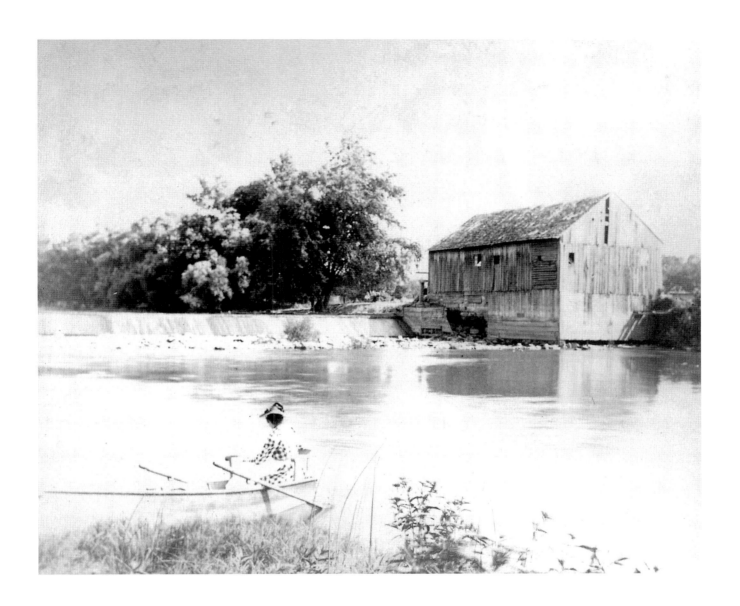

[Zoar] contains about 60 dwelling houses, 250 inhabitants, 1 store, 1 tavern 1 tan yard, 1 grist mill, 2 saw mills, 1 oil mill, a woolen and linen manufactory. . . . They have extensive water power, obtained by daming [sic] the Muskingum [Tuscarawas] river, which drives the machinery above enumerated.

—Warren Jenkins, *Ohio Gazetteer* (1841)

Soon after arrival, the Separatists dammed the Tuscarawas River to obtain waterpower for its industries. First among these industries was a sawmill, so the colonists could build houses. The sawmill seen here was built later, and this building was eventually converted to the Power House where, as early as 1902, a generator provided Zoar with electricity. Its foundation and part of the dam can still be seen on the river. The Tuscarawas River was originally called the Muskingum before this tributary was given its own name. *P223 Baus Collection.*

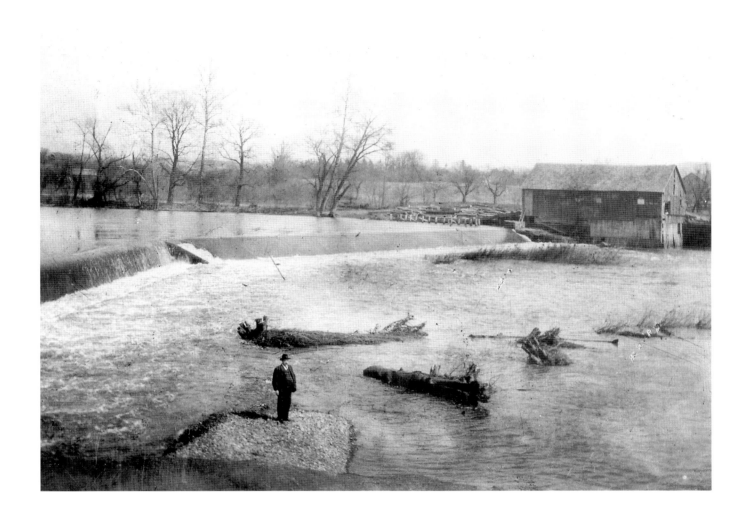

All manufacturing in Zoar is done by water power. The Tuscarawas River, by means of a dam, is made to flow with sufficient volume and swiftness to supply from thirty to forty horsepower to the various mills and factories, all of which are provided with machinery made by the Zoarites themselves in the large millwright shop which they have always maintained. One of the principal products of the Zoarites' land is flour, of which, after supplying their own wants, they ship large quantities to Washington, Baltimore, Cleveland, and Pittsburgh.

—Geoffrey Williston Christine, "Zoar and the Zoarites,"
Peterson's Magazine (January 1889)

The millstream brought water power to the various mills and was controlled by a guard lock, which is still extant. The southwest end of the Custom Mill can be seen in this 1898 photo. *P223 Baus Collection.*

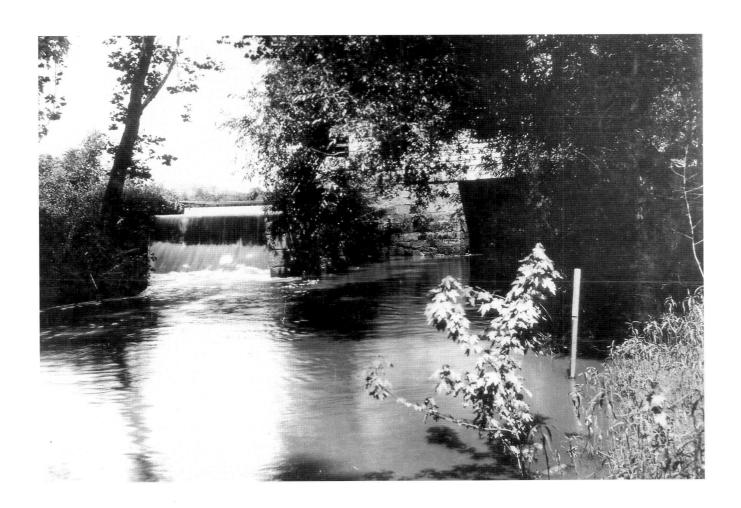

A mill, well-designed in the English manner and supplied all year long with sufficient water from the Tuscarawas River, by means of a very special canal, is capable of not only filling the rather considerable needs of the whole community, but also, in addition, of delivering every year two thousand barrels of flour for sale which is shipped by way of Cleveland to New York on the barge canal. This mill operates without strenuous work of human hands, since the machinery itself performs nearly all the labor. A large number of customers from all around Zoar call at this mill.
—P. F. D., "Harmony Builds the House . . ." (1832)

The special canal existed only for a short time. Boats could come right into Zoar and dock at the various mills. This building, the Custom Mill, was remodeled in 1845 with the newest machinery, and it served both the Zoarites and outsiders who brought their grain here to be ground. When the Zoar Levee was built in the 1930s, the building, no longer operated as a mill, was moved to nearby Zoarville and became Ehlers's General Store. *P223 Baus Collection.*

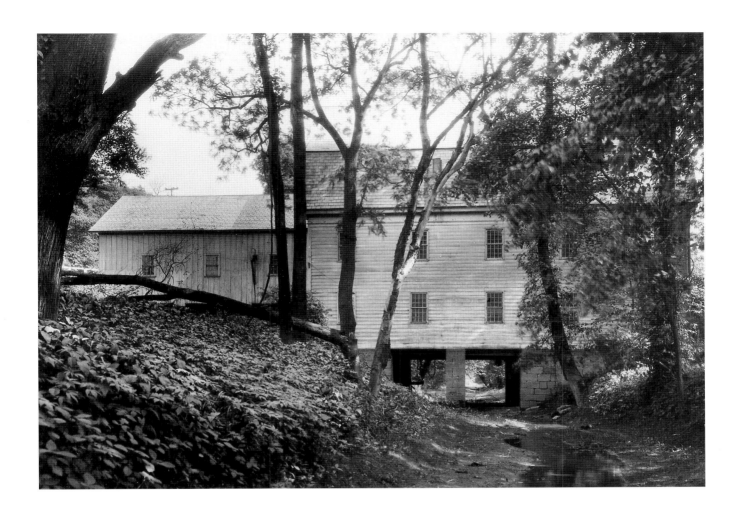

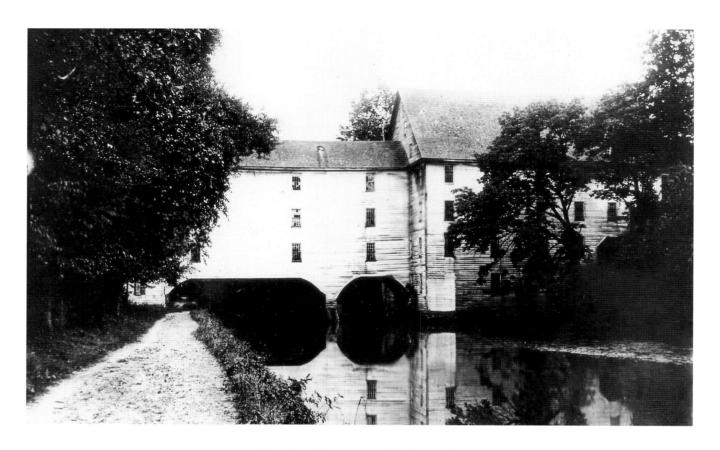

The old mill . . . spanned the beautiful stream. A great arch it was, that reached from one green bank to the other, while the mill itself, above, was unbroken and worked on with its rush, and buzz, and whirl of machinery within, just as though that was a common way of making mills to stand astride of noisy, onward-rushing rivers.
—Pipsey Potts, "A Queer, Quaint People, Part I,"
Arthur's Home Magazine (May 1882)

Pipsey Potts used a bit of poetic license. The mill spanned the canal not the river, although it did get its power from the river. Built in 1837, the mill allowed canal boats to load from a trapdoor under the arch. This mill was not as successful as the Custom Mill, however, and later it was used more for storage than grinding grain. It was torn down in the 1920s. Its foundations can still be seen along the canal. *P365 Properties Collection.*

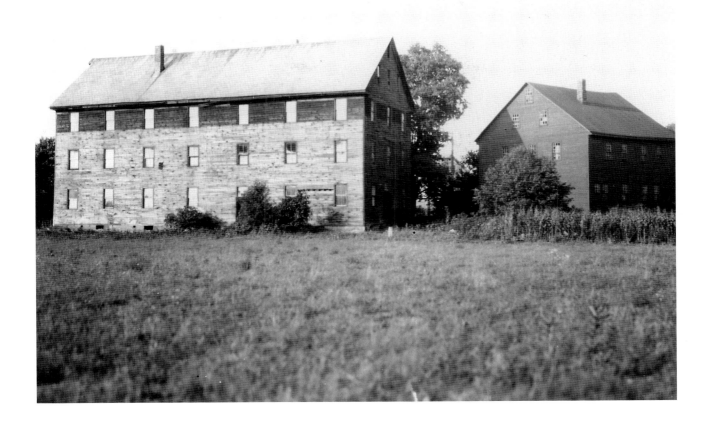

I was struck with surprise that they have been able to manage successfully com-
plicated machinery, and to carry on several branches of manufacture profitably.
Their machine shop makes and repairs all their own machinery; their grist-mills
have to compete with those of the surrounding country.
 —Charles Nordhoff, *Communistic Societies of the United States* (1875)

The Machine Shop is the building to the right. The larger structure is the
Woolen Mill. Both were located at the south end of the village and were de-
molished when the Levee was built in 1935. *P365 Properties Collection.*

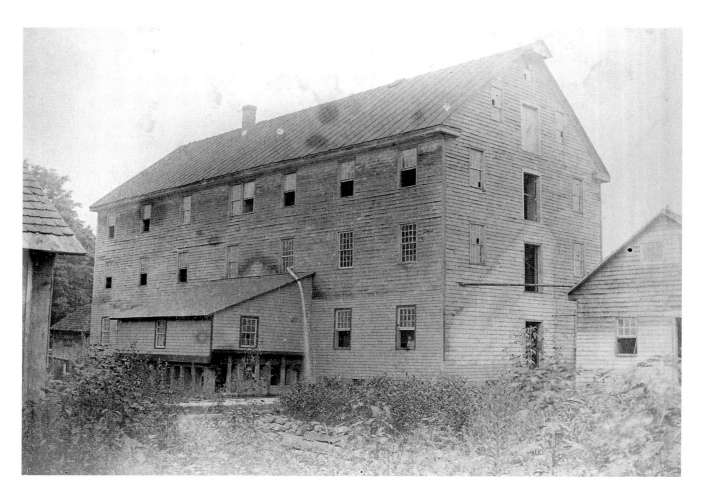

Out of this wool-yarn [mill] three other females, well-skilled in this procedure, manufacture on three especially equipped looms woolen materials, cloth, cassinets, and rugs, as well as cloth for garments for the community, or for sale, and also for a few customers, of which there would be many more if they could be served.
—P. F. D., "Harmony Builds the House . . ." (1832)

The Society's flock of sheep (which included merinos, prized for their high-quality fleece) produced an abundance of wool that was transformed into fabric at this mill. By 1845 the mill had acquired a Jacquard loom to create the intricately woven coverlets for which the Society became known. *AV9 Collection.*

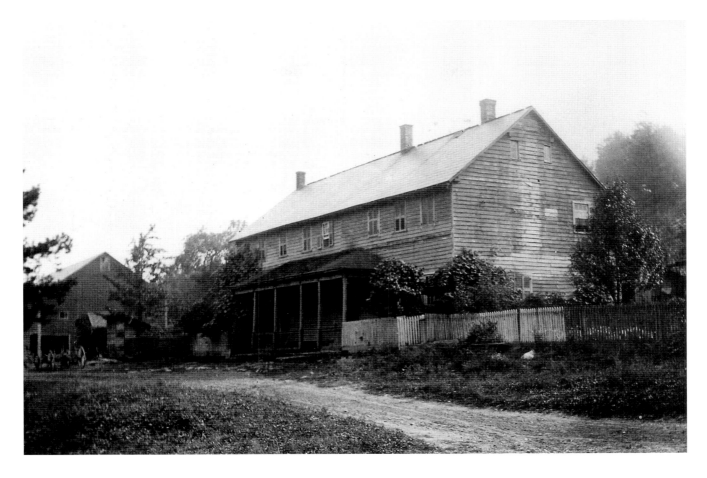

*A long wooden bridge is thrown across the canal and the river; close by is an inn,
built by the inhabitants, and called the Zoar Canal Hotel.*
—Maximilian, Prince of Wied, June 24, 1834, *Travels
in the Interior of North America* (1834)

In 1832 the Society built this structure as a hostelry for travelers overnighting on
the canal. It was soon found to be a bit too far from the eyes of the Trustees, who
could not control the uncouth "canawlers." It ceased its hospitality function,
which moved to the Hotel in town, and later became home to the manager of
the Canal Mill. It stands today and is now the Inn on the River restaurant. *P365
Properties Collection.*

We took the carriage, and drove through a romantic country to Bolivar to visit the furnace and iron works which belong to the settlement, though out of it, and carried on by hired persons not of the community.
—[Sophia Dana Ripley], "A Western Community," *New Yorker* (July 17, 1841)

The Society, wishing to expand its industries and make use of the cheap transportation afforded by the canal, opened Zoar Furnace, northwest of the village, in 1834 and soon thereafter acquired Fairfield Furnace, south of the village. As noted, the furnaces made use of outside labor and management as well as the plentiful iron ore and charcoal (the latter made by itinerants) found in the region. Such products as stoves, skillets, kettles, and other kitchen goods were created at the Foundry, located south of Zoar. This so-called charcoal iron was of mediocre quality and was quickly supplanted by the better ore later found in Michigan. The furnaces were defunct by the mid-1850s, and the foundry stopped working by 1875. This photo shows the remnants of the Zoar Furnace's slag pile. *AV9 Collection.*

"Abundance Everywhere, but with the Most Rigid Discipline"

ZOARITES AT WORK

To outsiders Society members seemed to work constantly, but never too hard. "Many hands make light work" was not just a cliché but a reality. Society enterprises, such as the Dairy, freed members to do other work (not everyone needed to milk a cow), and women's labor was just as important as men's.

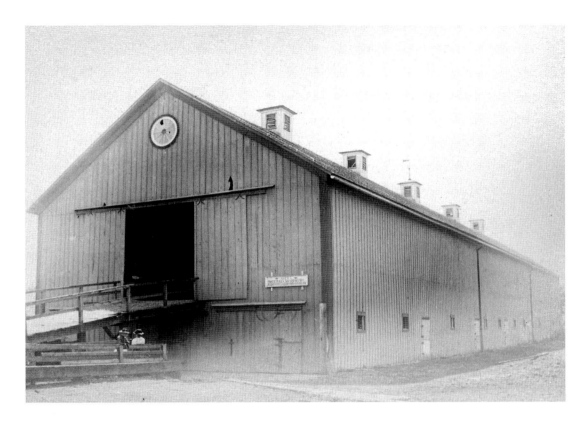

As the last hill was overcome, and I crossed the Tuscarawas river, I found my carriage in the midst of a large herd of cows which were being driven by herdsmen along the flats to a commodious stable, fit from its size and cleanly appearance to be termed a milker's palace. This cattle-barn was built in 1875, at a cost of $7,000. It measures 60 by 210 feet, and contains 108 stalls. An asphaltum walk, seven feet in width, extends the entire length of the stables, and the fifteen feet separating the two rows of mangers is also covered with asphaltum. The milking was entirely performed by women.

—The American Socialist (August 1, 1878)

This huge barn was greatly admired by all Zoar visitors. When the Zoar Levee was built for flood control in 1935, about fifty feet of the barn was removed. The barn stood until 1980, when its roof, weakened by lack of maintenance, caved in during a windstorm. The building was later dismantled. *AV9 Collection.*

They have about 90 cows which are all stabled[.] They are pastured off some ways from there and one man and two boys are continually watching them when they are drove [sic] home. Each goes to its place in the stable[.] A number of women are appointed to take charge of them[.] Each one has a certain number to take care of. They stand in thru [sic] the stable all night and they told me that these women slept there also. After the cows are gone in the morning they commence and clean out manure then they scrub and sweep out the stables which makes [them] look more like a kitchen than a stable. The milk is all carried to one house which is very convenient it being so fixed that they can set it [the milk] in the water. They put the milk in stone Crocks for to raise the cream. . . . which is different from any Yankee method that I ever saw.

—Moses Quinby, October 13, 1831, "Diary"

The Separatists were noted for their dairy products, selling them by way of the Ohio & Erie Canal as far away as New York City. They experimented with different breeds of cattle, finally settling on Durham and Devonshire. The dairymaids probably lived above the Dairy, not inside the barn. *AV9 Collection.*

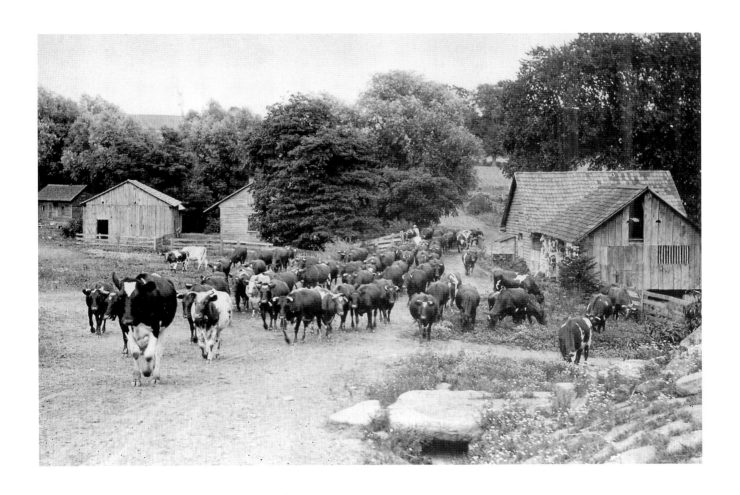

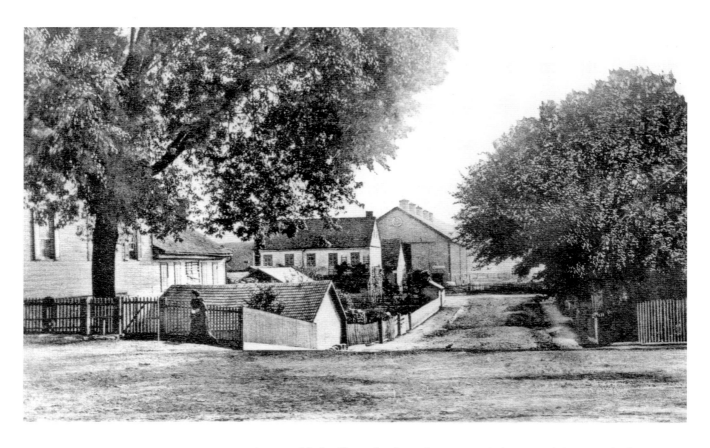

A venerable "milk-mother" in white cap and clogs, stood down in the lower story, and ladled out the strained milk into innumerable pails, each with its hieroglyphic sign on the cover, denoting to which household it belonged.

—Constance Fenimore Woolson, "The Happy Valley,"
Harper's Monthly Magazine (July 1870)

The Dairy, built behind the Store, was less than a block from the Dairy Barn. The Springhouse, under the Store, used an ingenious system of spring water flowing through troughs to cool the milk. Milk was picked up each afternoon, and empty pails were returned for refills. The "hieroglyphic signs" Woolson describes were Zoar house numbers. The roofed extension from the Dairy was a horse treadmill for a mechanical churn. The Cowherd's home and the Dairy Barn can be seen in the distance down Second Street. *P223 Baus Collection.*

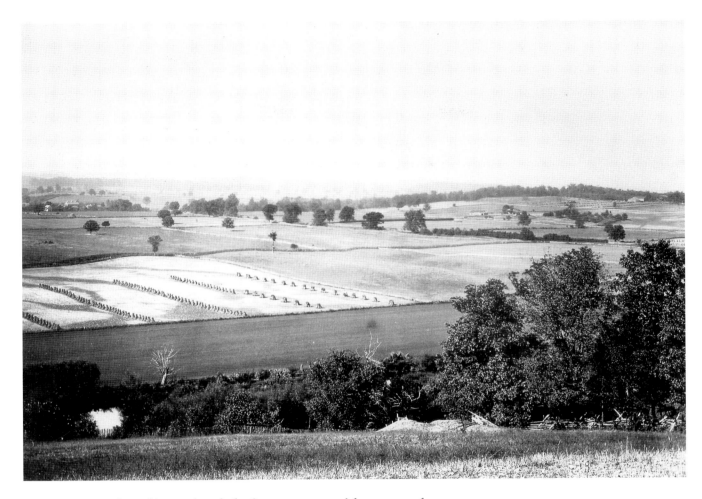

At Zoar, we were favorably struck with the fine appearance of the crops on the very extensive grounds belonging to the community. The corn was the best we had seen in this season and the wheat, oats, and grass were equal to any not on better land.
—[M. B. Bateham], *Ohio Cultivator* (August 15, 1848)

The Society farmed much of its land in grain, both for its own use and as a cash crop. This may be the "200-acre wheat field" north of the village. Many fields were given names for identification. Some land was leased to outsiders to farm on shares. *P223 Baus Collection.*

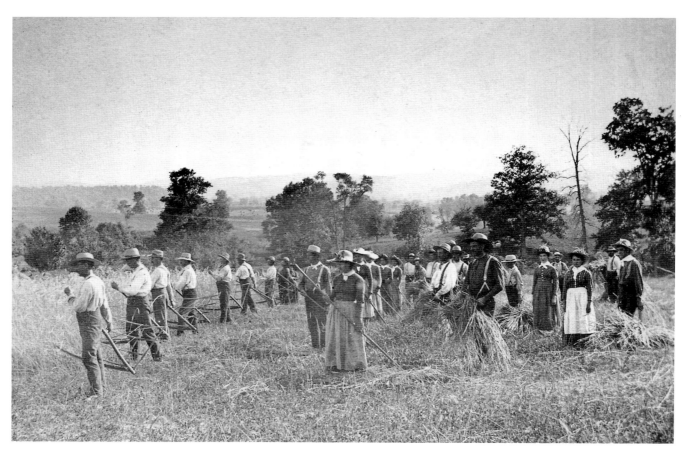

[The women of Zoar] delve into the gardens and toil in the fields, carry huge bundles on their heads and rake with their stout arms. At the time of our visit . . . the Zoarites were gathering in their grain . . . and the girls were following in the wake of the rakers over the field, picking up every straw and head of wheat, in order that nothing should be lost or wasted.

—"The Separatist Society," *Ohio Statesman* (September 18, 1859)

Women labored alongside men performing many traditionally male jobs and scandalizing the Victorian writers outside the Society. In a communal society the labor of all members is necessary for survival. *P365 Properties Collection.*

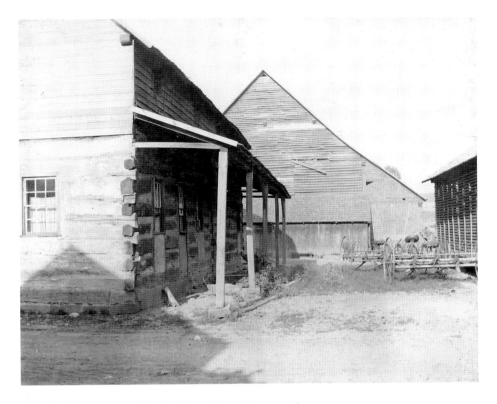

The threshers raise a cloud of dust about the great barn.
—Alexander Gunn, January 5, 1892, *Hermitage-Zoar Note-Book* (1902)

We were attracted to the sound of flails. Really and truly, the rhythmic beating of the flails upon the barn floor! . . . Long, long ago it was a familiar noise—one that we had never expected to hear again."
—Pipsey Potts, "A Queer, Quaint People, Part II," *Arthur's Home Magazine* (June 1882)

Women also worked as threshers, using the hand flail, which was a short stick hinged onto a longer stick with a leather thong that was used to beat the grain from the straw and chaff. This is another job usually done elsewhere by men but done in Zoar by women. This large building in the distance is the Granary, where the threshing was done, mainly in the winter. *P365 Properties Collection.*

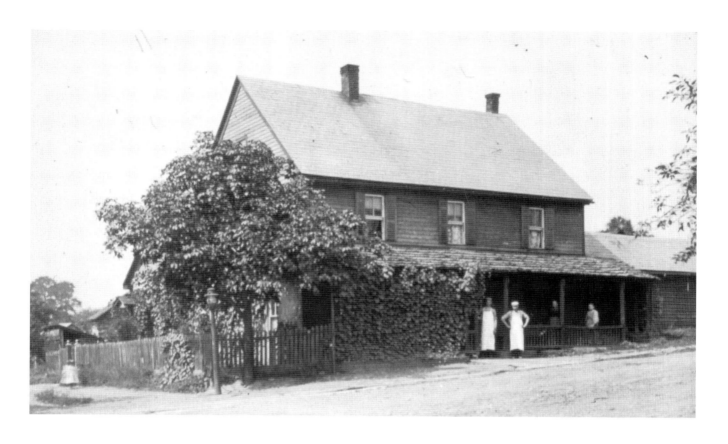

The food is plentiful, plain and wholesome. In the way of bread, there is always white bread, brown bread, and what is known as "Zoar bread"—this last being peculiarly dark in color and possessing the quality of holding its moisture remarkably long after it has been cut. A piece of bread, of whatever kind, is always of such generous proportions that it is a stretch of fancy to call it a mere slice.
—Robert Shackleton, "In Quaint Old Zoar,"
Godey's Magazine (November 1896)

The Bakery was another Zoar enterprise where labor was maximized. Two people baked for the entire Society and the Hotel. Bread was picked up each day by members' children returning from school and wrapped in linen cloths embroidered with house numbers. No money changed hands. The Bakery continued operation for a few years after the Dissolution. *Zoar Collection.*

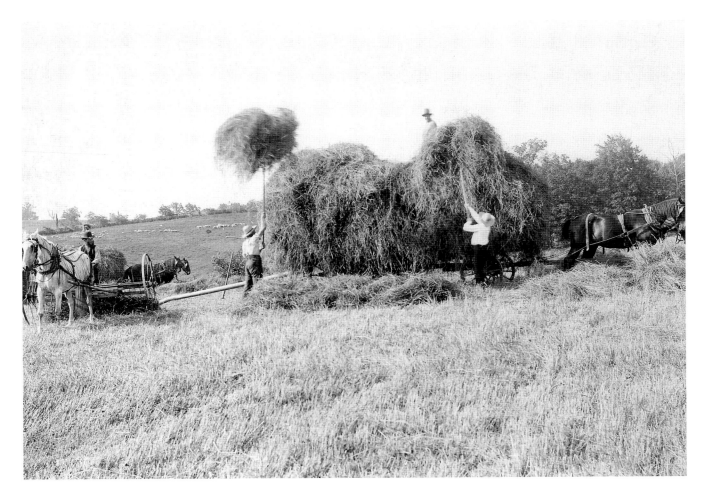

The traditional Christian holidays did not fill him [Bimeler] with much respect, as he thought one day as sacred as another. Sunday he did not even consider a day of rest, because, as he remarked, the crops sown on this day did just as well as those sown on any other day. If nature makes no distinction in this respect, it was not necessary for man to do so.

—Karl Knortz, *Aus der Mappe eines Deutsch-Amerikaners* (1893)

Most Sundays were spent at the Meeting House. However, harvesting was an exception. Everyone was expected to help out because time was of the essence, and it was to the benefit of all in the community. *P365 Properties Collection.*

This store and the hotel opposite formed the center of the village life and here the male members who were so inclined spent their lounging hours, smoking, chatting and discussing the affairs of their community.
— E. O. Randall, *History of the Zoar Society* (1899)

The Store was not only for Society members but also for outside neighbors and hired workers, who received Store credit as part of their wages. The Post Office, located here, was a hub for news of the world outside. Until the last years of the Society, tobacco was banned for members, although it had always been sold at the Store. *P365 Properties Collection.*

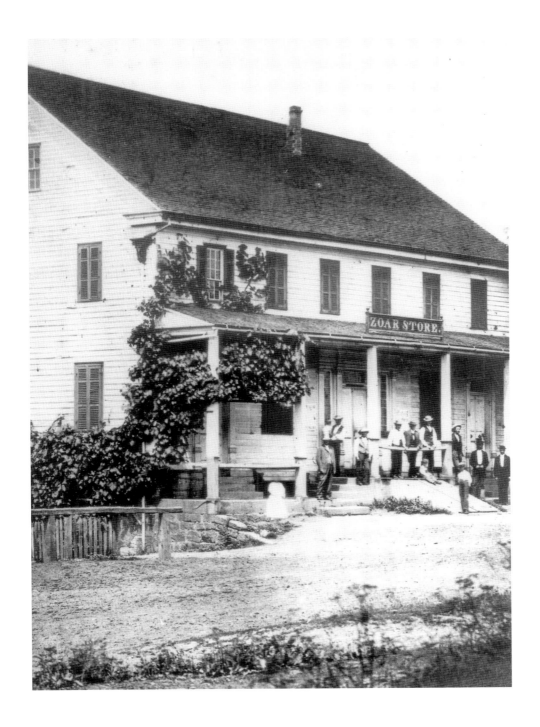

In a cartwright shop, . . . three to four trained cartwrights manufacture out of wood suitable for this purpose and grown on the Zoar land itself, heavy and light carriages of all kinds, and implements . . . useful in farming and domestic economy. Considering the extensive agricultural activities and economy of Zoar, the need for such items is not small. Nevertheless this cartwright shop also manufactures items for customers from nearby and for sale.

—P. F. D., "Harmony Builds the House . . ." (1832)

The Wagon (or Cartwright) Shop built all sorts of vehicles, including a "hack" for transportation to the two-mile-distant Zoar Station depot and a carriage for Joseph Bimeler, who was lame. This latter vehicle, although it was modest by most accounts, caused jealousy among some members, who had no personal vehicles at their command. Main Street, the Tailor Shop, and the larger Zoar Store can be seen in the distance. *AV9 Collection.*

The garbage of the dwellings was gathered each day in a wagon and carried off.
The home interiors were scrupulously scrubbed and dusted.
—E. O. Randall, *History of the Zoar Society* (1899)

This photo, dated 1880, shows John Opp standing in his specially constructed wagon in the Hotel courtyard. Household garbage, manure, and other organic wastes were composted and used on gardens for fertilizer. *P223 Baus Collection.*

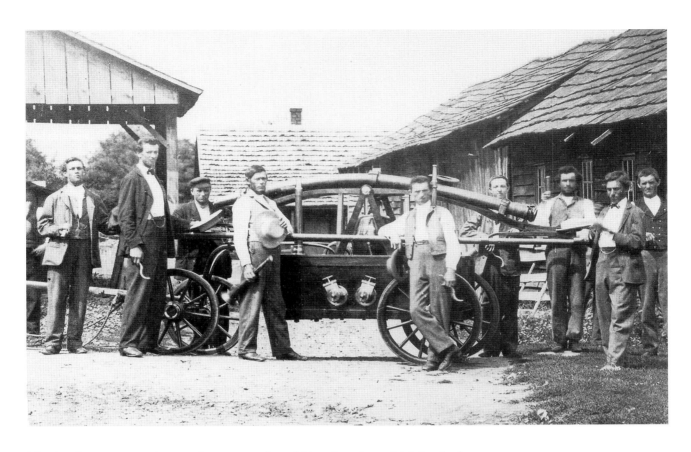

The fire department is the proud possessor of an old hand engine, which has had no exercise since the foundry burned in the early eighties.
 —George B. Landis, "The Society of Separatists of Zoar, Ohio," *Annual Report of the American Historical Association* (1899)

Dated 1869, this photo is one of the earliest in the Ohio Historical Society's collection. The Fire Brigade existed as early as 1848 and kept its own records. The engine was stored at the Hotel Livery Stable and, after the village incorporation, at the Town Hall. *P365 Properties Collection.*

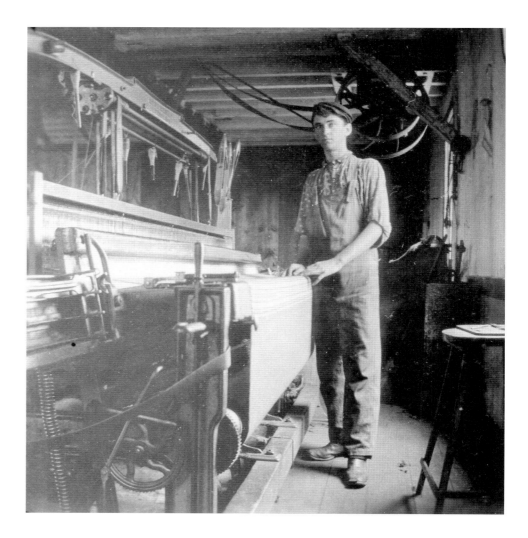

We went to the weavers, where we found the good man and his wife, who supply the society with woolen cloth, working in their pleasant airy rooms, where a child of twelve tended the baby.

—[Sophia Dana Ripley], "A Western Community,"
New Yorker (July 17, 1841)

August Burkhart (1880–1935) stands at the blanket loom in this late photo. *P223 Baus Collection.*

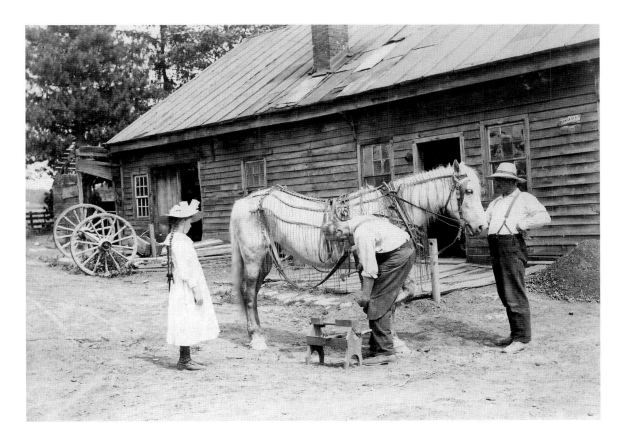

Here three blacksmiths carry out the necessary work for the community—which is not insignificant—and also serve a goodly number of customers from the neighborhood. For their work they make use of coal deposits, quite common in their land and of a quality well suited for a smith's work.

—P. F. D., "Harmony Builds the House . . ." (1832)

Blacksmithing, or metal forging, was important to every community during the nineteenth century, and Zoar was no exception. The Blacksmith Shop, adjacent to the Wagon Shop, at one time contained three forges. The blacksmith worked closely with the cartwright at the Wagon Shop to manufacture hardware and iron tires for vehicles. Supplemental blacksmith shops were located at the iron furnaces and at the Canal Hotel, the latter used for shoeing the mules and horses that drew the canal boats. *P223 Baus Collection.*

The sound of the horn at day-break calls them to their labors. They mostly work in groups, in a plodding but systematic manner that accomplishes much. Their tools are usually coarse, among which is the German sythe [sic], short and unvieldy as a bush-hook, sickles without teeth and hoes clumsy and heavy as the mattock of the southern slave. The females join in the labors of the field, hoe, reap, pitch hay and even clean and wheel out in barrows the offal of the stables.
—Henry Howe, *Historical Collections of Ohio* (1847)

The Assembly House was the gathering place for those Society members who did not have a regularly assigned task. A bell in the cupola called the workers to receive their daily jobs. Before this home was constructed in 1858, a pottery horn (now on display at Number One House) was used to summon the laborers. Legend has it the horn cracked one Christmas morning, a day on which the Society had labored like any other; thereafter the Society no longer worked on Christmas. *P365 Properties Collection.*

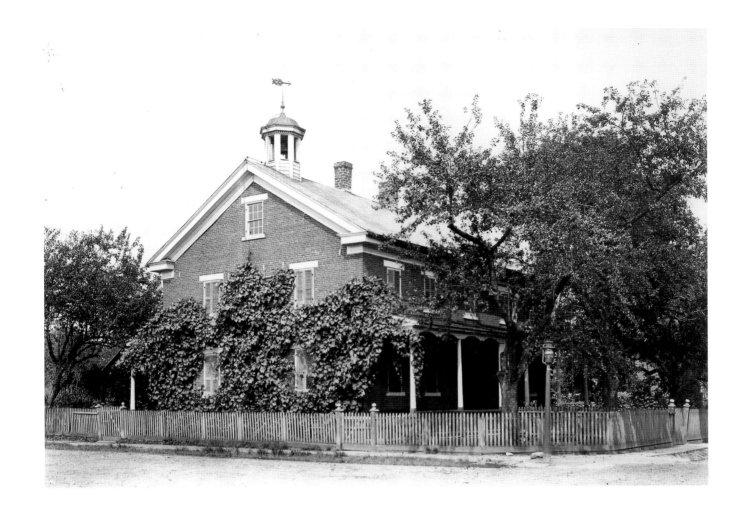

The children go to public school until they are 17 years of age, when they are put to work. The two schoolrooms are well furnished with patent desks, apparatus and organ. Only the common branches are taught. In the primary grade three days are given to English and two to German, which is the common language of the people. This use of dual speech may make the children appear backward in their studies. Until 1874 only German was taught in the school. No one in the community has ever taken a higher course, except the present school-teacher, who attended a local normal school in a neighboring town, but even he never withdrew the winding sheet from the dead languages.

—George B. Landis, "The Society of Separatists of Zoar, Ohio," *Annual Report of the American Historical Association* (1899)

The Separatists had a close relationship with Lawrence Township, which ran the school system. The Zoarites furnished the building, the township paid the teacher, and the Society set the rules, as long as nonmember children in the surrounding area could also attend school. Parents from areas outside Zoar sent their children here to learn German. Some teachers, such as Levi Bimeler, were Society members; others were outsiders. This is the second schoolhouse, built in 1868. The photograph is undated. The School today is restored and used as a community center. *Zoar Collection.*

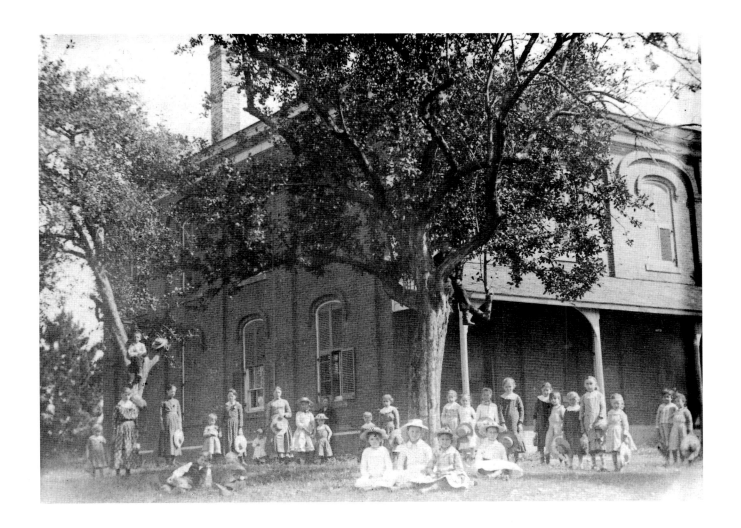

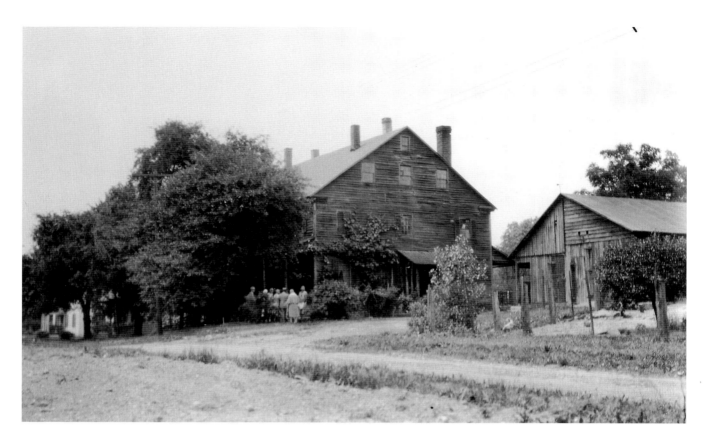

Near is the great, rusty-red old farm-house. The hired yokels live there and when the iron bell gives signal for their meals they troop heavily in, hardly less noisy than their horses.

—Alexander Gunn, May 20, 1896, *Hermitage-Zoar Note-Book* (1902)

The Bauer, or Farmer's, House was the dormitory for the hired hands and was located conveniently next to the horse barns. One of these workers' primary occupations, especially in later years, was to do the heavy labor of plowing the fields. Many German immigrants got their start as hired workers in Zoar. Some came with letters of introduction from Separatists' relatives in Germany, while others learned of the village by word of mouth. The Zoar community, with its comfortable German language and customs, was a gentle transition into life in America. *P223 Baus Collection.*

I drove on for a few rods, past a number of fruit trees, secluding buildings, which revealed the reason of [sic] Zoar being called a "little city hidden in an apple orchard."

—*The American Socialist* (August 1, 1878)

The growing of fruit trees, especially apple trees, was a Zoar specialty. Simon Beuter, Zoar's long-time gardener, developed two varieties of fruit named for the Society, the Zoar Sweeting Apple and the Zoar Beauty Pear. *P365 Properties Collection.*

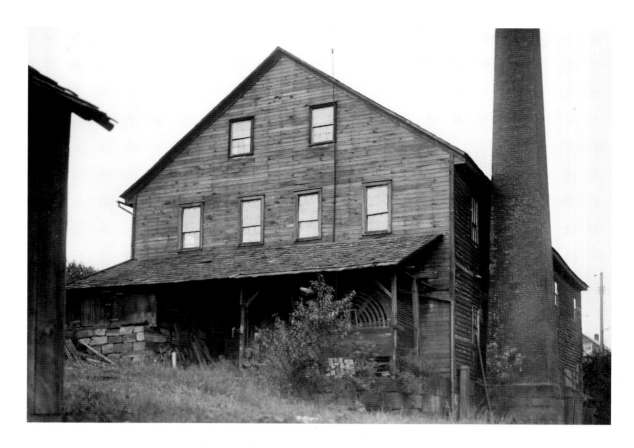

Not far from the horse stable was the cider mill, which was in full blast, producing an article of superior quality. When in season this was daily carted about the village in a low-wheeled large-barrelled conveyance, precisely resembling a small sprinkling wagon. It stopped at every door and the inmates were supplied with a pail full or more, as was required.

—E. O. Randall, *History of the Zoar Society* (1899)

The Cider Mill, built in 1854, processed the raw apples into cider. In the best German manner, every windfall apple was saved to be made into cider. A circular wooden apple washer can be seen on the porch in this photo. The Cabinet Shop, where craftsmen created the distinctive Zoar furniture, was on the second floor and made use of the Cider Mill's steam engine for its lathes. *P365 Properties Collection.*

"In a Singularly Neat and Handsome Manner"

THE ZOAR GARDEN

The Zoar Garden was the Separatists' most public manifestation of their faith, providing both resident and visitor with a place to relax and reflect. Its religious symbolism and lush beauty showcased the Zoarites' considerable horticultural skills.

In the Centre of these lots they have their Gardens and on the out corners and outside is their houses and shops[.] On the North side of this is [a] green House Containing almost all kinds shrubs some orange and Lemon trees with all kinds flowers. In the centre of the Garden is a circle of Rose Bushes[.] Perhaps 20 ft in circumference in the middle is a bed of flowers of all kinds planted in circles which makes it quite beautiful[.] There are twelve walks four feet wide beautifully lined with flowers and s[h]rubs and all terminating in [the] centre. Besides these there are three walks running each parallel with the square at equal distances from the edges and each other[.] This accordingly will make some of their beds (which contain common garden vegetables such as beets carrots, etc.) in the form of a triangle others of a right angle and many other shapes equaly odd.

—Moses Quinby, October 12, 1831, "Diary"

This early description of the Zoar Garden gives a rough outline of its geometric shape, which was symbolic of the New Jerusalem in Revelation 21. The center tree is the Tree of Life, or Christ, and the circle (here described as formed by rose bushes; later observers say a hedge) is Heaven. The twelve slip junipers seen in this late photo represent the Apostles. The twelve radiating walks symbolize our paths in life. The path surrounding the entire Garden is the World. To be saved, one has to get on a path that leads to Christ and not go astray. The Ohio Historical Society maintains the Zoar Garden in this tradition. *AV9 Collection.*

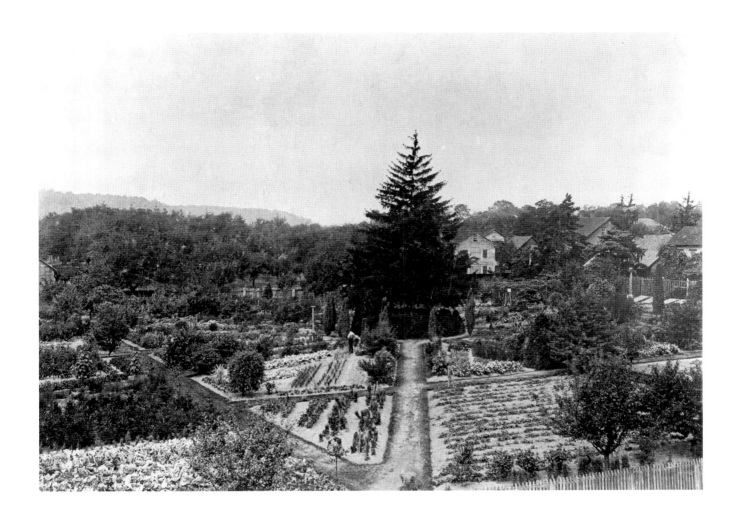

After diner we walked into a garden containing about one acre. It appeared verry neat and pleasant, being well supplied with walks which cross each other at right angles, with the intermediate spaces under skillful cultivation, presenting to the eye the various fruits and vegitables of the season. . . . This garden contains a hot house in about which were a variety of plants and small trees that require its protection during winter, among which were several lemon trees, one of which was loaded with lemons, of handsome size some being verry large.

—George Washington Hayward, "Journal of a
Trip to Ohio" (September 26, 1829)

This is the first description we have of the Garden and Greenhouse. Early depictions of the Garden describe vegetables among the plantings; later ones just mention flowers and sometimes strawberries. *P233 Baus Collection.*

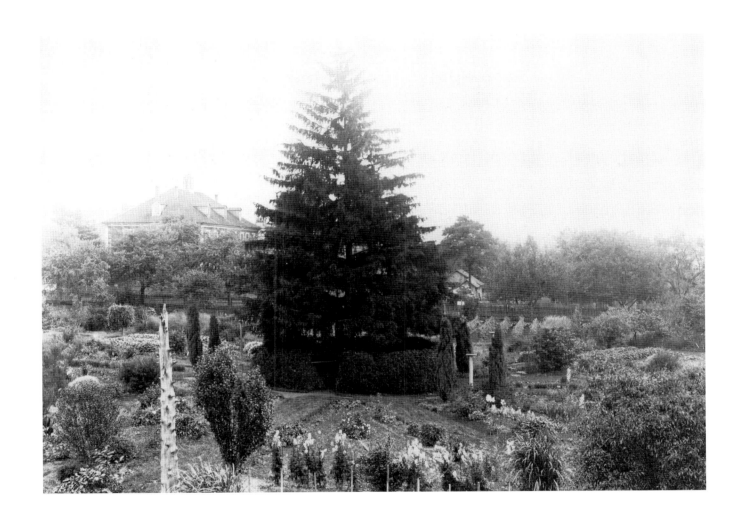

A very large pine-tree, symmetrical and thickly set with branches—a very dense, dark mass of sweeping tassels—occupies the prettiest location in the garden. Around it is planted a thick, low hedge of arbor vitae, which rises up and meets the drooping branches of the pine.

—Pipsey Potts, "A Queer, Quaint People, Part II"
Arthur's Magazine (June 1882)

This is actually a Norway spruce, not a pine. The tree in today's Garden was replanted when the Garden was restored in 1929. *P223 Baus Collection.*

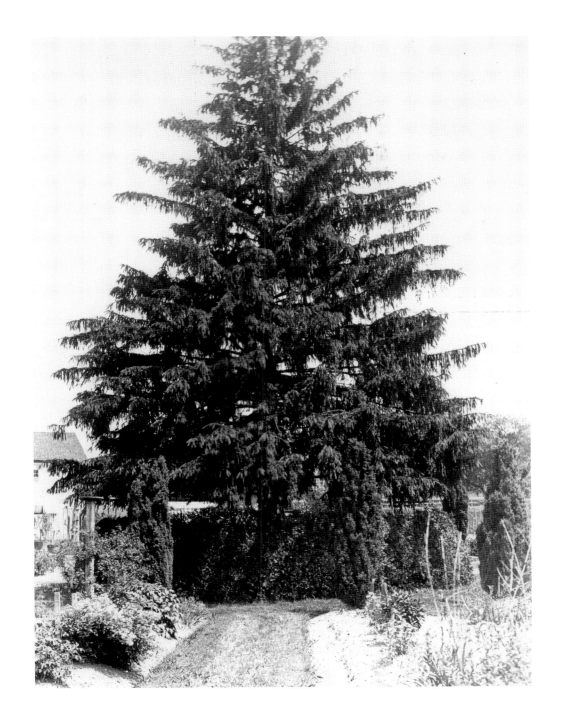

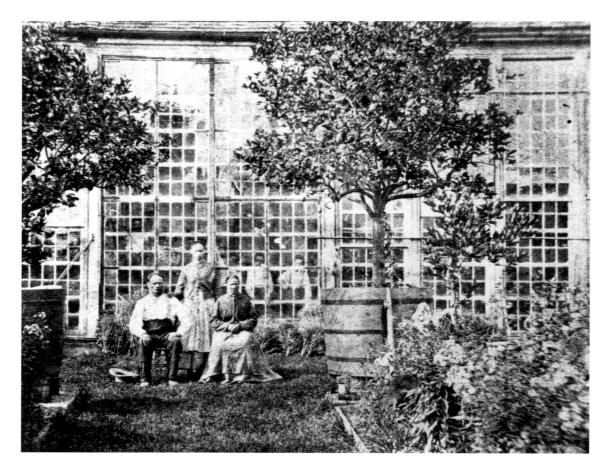

The recreation of the community has also been provided for in a very extensive garden in the centre of the town; which, besides abundance of flowers and vegetables, contains greenhouses for citrons and pomegranates. It is much frequented by strangers who take up their abode in the little inn, where they find a good table in the German style.

—"The Colony of Zoar," *Penny Magazine* (October 26, 1837)

The citrus fruits and other exotic plants were cared for in the many-windowed Greenhouse, seen here in its original configuration. Heat for the winter months was provided by burning charcoal in an underground brazier. Pictured may be the head gardener, Simon Beuter, and his wife, Anna Maria. *AV9 Collection.*

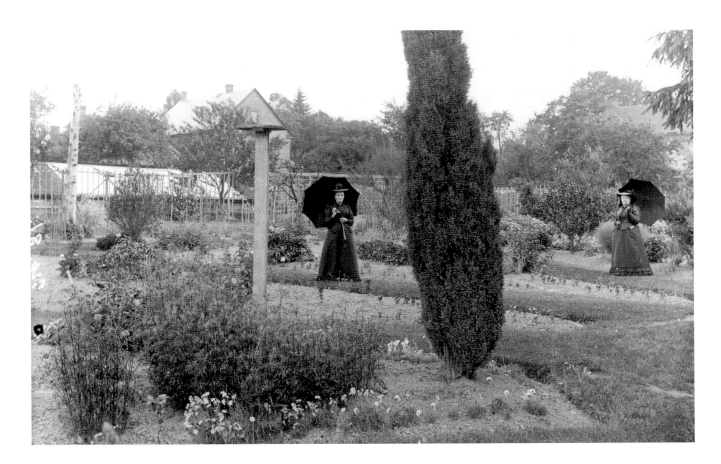

Within a few minutes' walk of the hotel, there is a fine public garden and greenhouse, both of which are always open. There is no prohibitory "No Admission" or "Hands Off" upon anything. Everyone is free to enter at any time and roam about at will. The garden is tastefully laid out and contains some noble trees and elegant shrubbery, while the greenhouse boasts a large collection of choice plants and flowers.

—Geoffrey Williston Christine, "Zoar and the Zoarites,"
Peterson's Magazine (January 1889)

The Garden was always a favorite location for Zoar's visitors, who strolled along the pathways. The raised platform on the left may have held a birdhouse or beehive. Vines were trained to climb the latticework near the fence. *P365 Properties Collection.*

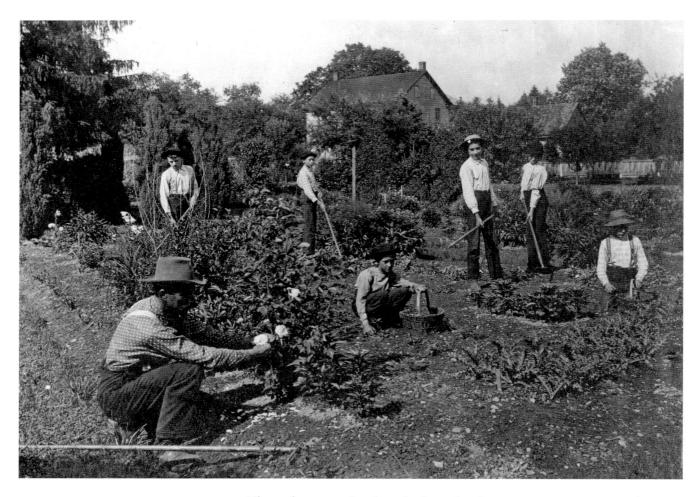

The garden is quite handsomely planned and contains many curiosities in the flower and shrub line, both from the temperate and tropical zones, though it wants work.
—J. B. L., "The 'Zoar-ites' or Separatists," *Summit Beacon* (July 31, 1862)

Simon Beuter, the Society's gardener, often complained that all he got were the old men and the young boys to help him cultivate the Garden. Here he is joined by the latter. *P365 Properties Collection.*

In their beautiful garden, which has for many years been the admiration of visi-
tors, we regret to find some evidence of neglect, or rather a want of taste and
enterprise, not in keeping up with the progress of the times, or with the increase
of wealth of the association. Much of the interest of the garden is lost by the lack
of new and improved varieties of flowers, shrubs, and green house plants, which
have been produced or introduced into cultivation within the past ten years, and
add so much to the beauty of good modern gardens.
<div align="right">

—[M. B. Bateham], *Ohio Cultivator* (August 15, 1848)
</div>

With the death of Joseph Bimeler, the community started to look backward
rather than forward and was no longer as "progressive" as it was once thought
to be. As tourism to Zoar increased, some summer visitors were housed at the
Garden House when the Hotel was full. To provide more room, the Green-
house's roof was raised and a second floor of bedrooms was added and the
large sash windows removed. *P223 Baus Collection.*

One of the most interesting attractions in Zoar is their garden. It is of ample dimensions, and almost every species of fruit, shrubbery, plants and flowers are cultivated in it—the indigenous plants in the open garden, the natives of foreign and more congenial climates in a greenhouse. Among the fruit trees I saw about a dozen lemon bushes loaded with fruit, now nearly ripe. These bushes are nurtured in the cold season of the year in the greenhouse, from which they are not removed in the spring season til after the disappearance of frost. At the time I visited the garden the many visitors were there admiring the flowers and plants and promenading the walks. A considerable portion of the fashion and beauty of Massillon were there, nearly the entire population of Bolivar, several from New Philadelphia and Canal Dover, and numbers from other places; it is consequently becoming a fashionable resort.

—Tuscarawas Advocate (July 7, 1836)

An orange tree from the Greenhouse is planted temporarily among the flower-beds. *P223 Baus Collection.*

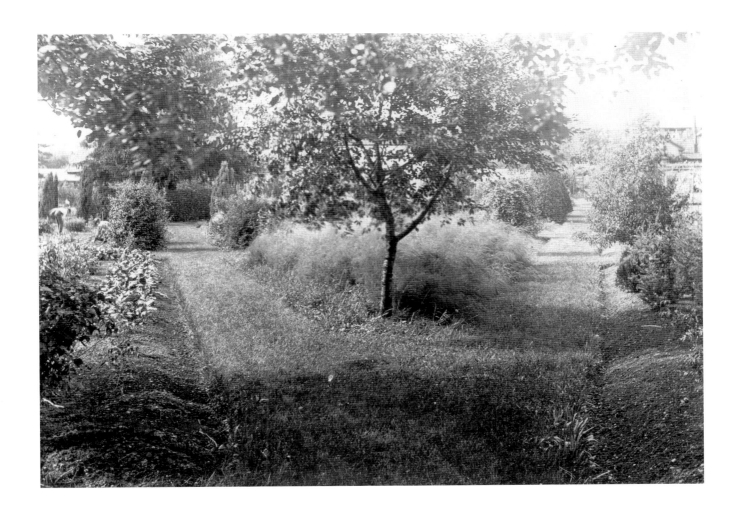

First we went through the garden of two acres with its turfed walks, grape-vine arbors, with seats under the shade, and came to the green-house, surrounded with large lemon and orange trees. The collection of plants is small, but in high order; and as it is the only establishment of the kind in the vicinity, persons come a hundred miles to purchase flowers and seeds from it.

—[Sophia Dana Ripley], "A Western Community,"
New Yorker (July 17, 1841)

These are not the citrus trees described but large cedar trees. *P223 Baus Collection.*

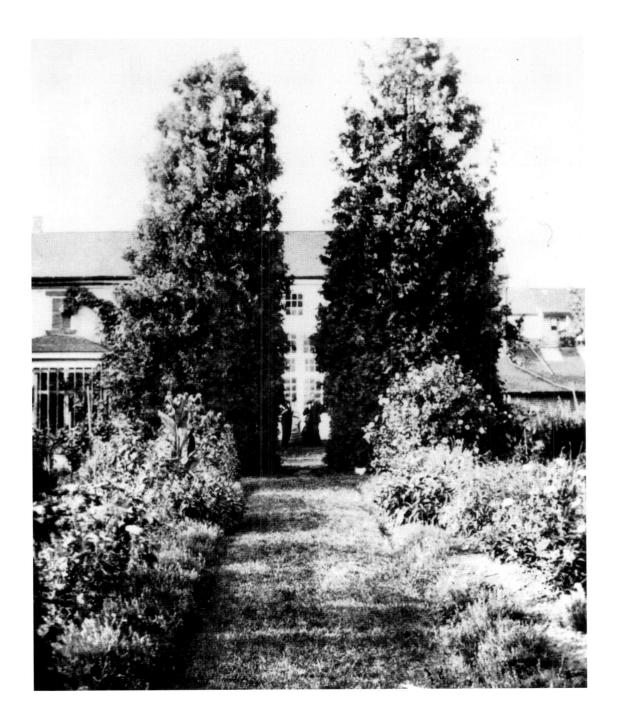

The flower garden . . . is tastefully laid out and carefully kept. It forms during the summer (besides the pleasant surrounding of Zoar) the center of attraction for rest-seeking strangers from neighboring towns.
 —Karl Knortz, *Aus der Mappe eines Deutsch-Amerikaners* (1893)

This Springhouse, at the corner of Third and Park, was part of the village water system. Seven springs on the hill by the Meeting House fed a system of wooden water pipes that, using gravity, supplied water to the entire village. The Springhouse was restored in 1994. *P365 Properties Collection.*

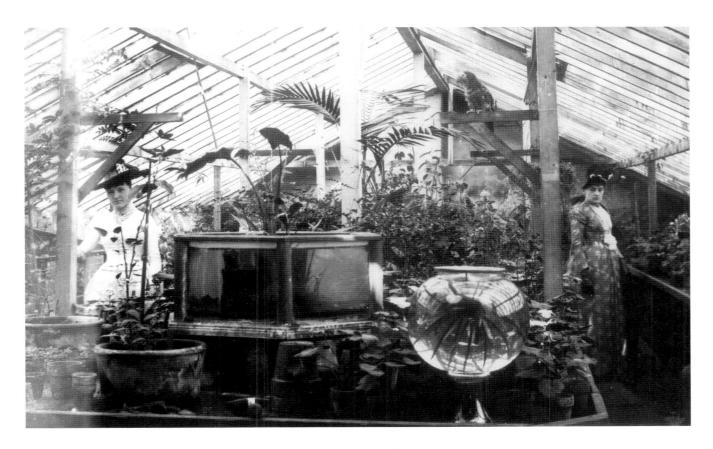

The hot house is rendered a curiosity, not merely by the neatness with which it is conducted, but by the extensive variety of plants and fruits that it contains. The house is considered a great public convenience, inasmuch as it enables all who wish to furnish themselves not only with choice houseplants of every description, but to return them there for preservation against the frost during the winter. This is done by inhabitants of Cleveland, and other points on the lake shore, and the line of the Ohio and Erie canal.

—Warren Jenkins, *Ohio Gazetteer* (1841)

The older Greenhouse was eventually consumed by the residence portion of the Gardener's house. By 1895, when this photo was taken, a smaller, more familiar-looking glass Greenhouse had been constructed on the east end of the Garden House. *P365 Properties Collection.*

"The Summer Boarder"

THE ZOAR HOTEL

Tourism was both a blessing and a curse to the Separatists. The savvy merchant in them appreciated the income, but the communard only wanted to be left alone, not gawked at. Moreover, the compelling lure of the world brought here by the visitors enticed many members to leave Zoar, thus hastening the Society's demise.

They have a splendid hotel with a cupola, conveniently, and some respects, elegantly arranged and furnished, possessing numerous attractions to travellers and visitors not to be found in many large cities. I always take this place in my route north, and enjoy quite a luxury in partaking of the fine accommodations and excellent fare here presented; nearly everything is of their own production.
—"A German Village in Ohio," *Portland (Maine) Tribune*
(November 25, 1843)

This Hotel, built in 1833, eventually supplanted the Canal Hotel. At first it served canal and, later, rail travelers, but eventually it became something of a summer resort. The cupola allowed the Zoar Trustees as well as visitors to view the surrounding countryside. The Hotel is now being restored as a museum and visitor center. *AV9 Collection.*

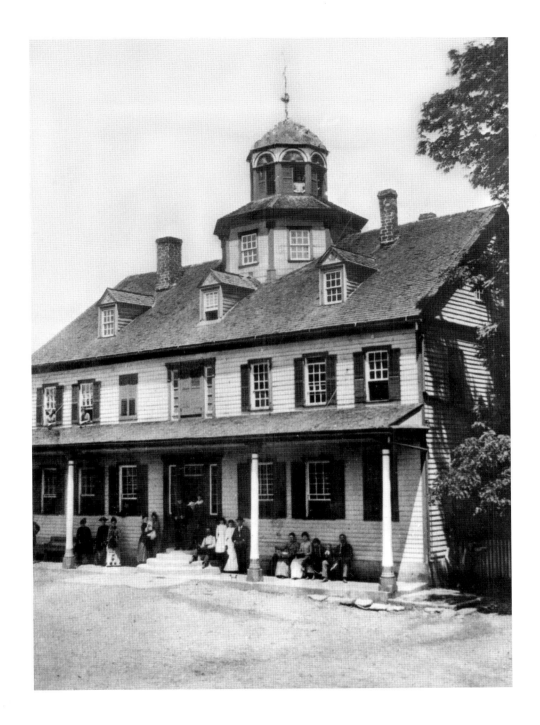

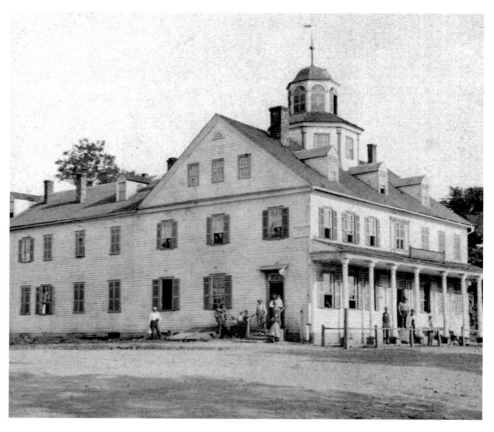

A few steps farther on, and my young charioteer pulls up . . . before the door of a large frame structure painted white, with a massive oaken door in the centre and surmounted by the white cupola which for some time past has been leading us on like a beacon-light.

—Geoffrey Williston Christine, "Zoar and the Zoarites,"
Peterson's Magazine (January 1889)

At one time the Hotel had eight front porch columns. Sometime before 1880 four columns were removed and metal rods were attached to the building to anchor the porch. Hitching rails lined the front. *AV9 Collection.*

A rosy youth appeared, to show us to our rooms—a series of little cells, each with its lofty bed and steps, one window, with snowy, prim-folded curtains, [and] one chair. . . . The gayly colored counterpane was woven with figures of strange birds; the snowy linen was marked in red with the two letters "W. H."—Wirth-haus; and the yellow-painted floor, blue cased windows, and scarlet door made the little cell quite a gay abode.

—Constance Fenimore Woolson, "The Happy Valley,"
Harper's Monthly Magazine (July 1870)

The second floor of the *Wirth-haus*, "hotel" in German, is shown here with its 1850s and 1880 additions. *AV9 Collection.*

I arrived at the Zoar hotel, an overwhelmingly large hostelry for so small a town. The old hotel, erected half a century ago, stands on the main street, and extending east on the corner for fully a hundred and fifty feet, has had added to its front a modern structure three stories in height and containing some fifty commodious rooms. A wide veranda surrounds the new addition on the west front and south side. This new wing was added some five or six years since to accommodate the large number of summer boarders who frequent Zoar to spend a longer or shorter time enjoying the beautiful scenery, the rural drives of the surrounding country and the quaint and quiet life of the village.

—E. O. Randall, *History of the Zoar Society* (1899)

Unlike the other Zoar buildings, the 1892 Zoar Hotel addition was not built by the Separatists themselves and was not in their traditional German style. The builders consciously aped the prevailing Queen Anne architectural style, with its turrets and shingles. The ready cash supplied by the tourists who visited the Hotel kept the Society afloat, at least temporarily. *P365 Properties Collection.*

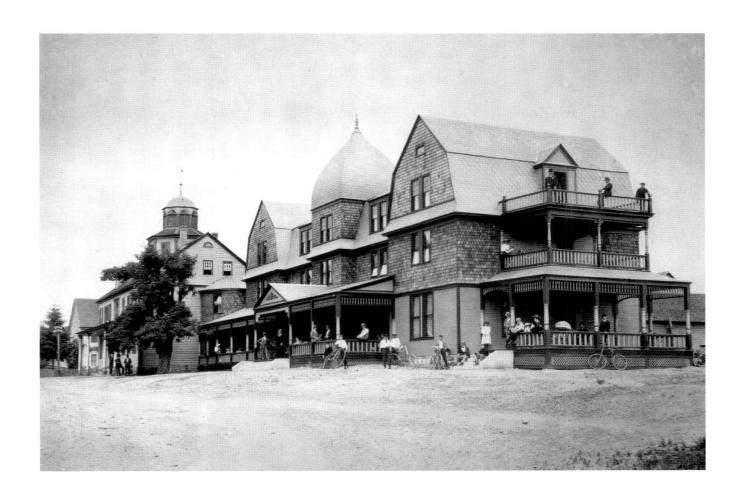

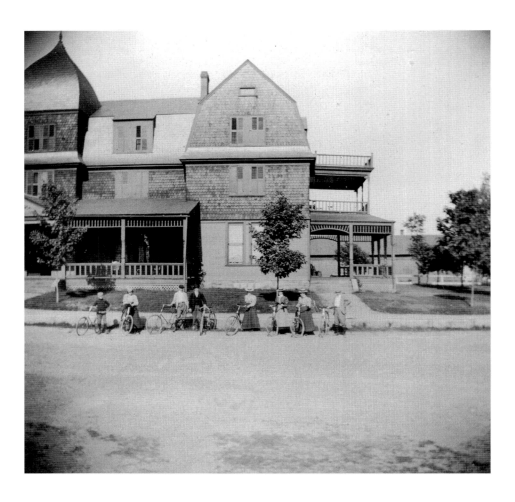

Now the summer boarder infests the village. I shun the hotel, with its mob of strange faces and childhood in its only offensive form.
　　　　　—Alexander Gunn, July 20, 1893, *Hermitage-Zoar Note-Book* (1902)

The Hotel was the destination of choice for many "wheelmen" (and women) who participated in the bicycle craze of the 1890s. This Victorian addition was razed in 1947. *AV9 Collection.*

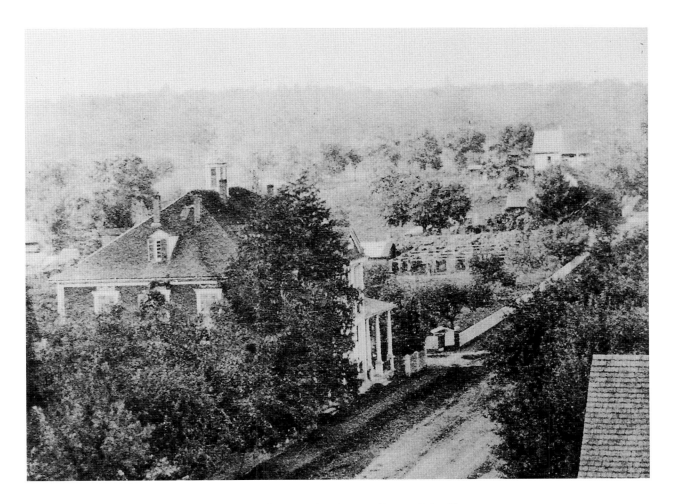

From the third floor, a spiral staircase winds around a large pillar and finally brings us into a round cupola completely encircled by large windows. A view of rare loveliness spread out at our feet. . . . The picturesque white houses of the town, ornamented with clinging vines, and the gayly- plumaged birds . . . make up a prospect well worth traveling far to see.

> —Geoffrey Williston Christine, "Zoar and the Zoarites,"
> *Peterson's Magazine* (January 1889)

Photographed before the 1887 construction of the Town Hall, this view shows the Number One House and the Garden. *P223 Baus Collection.*

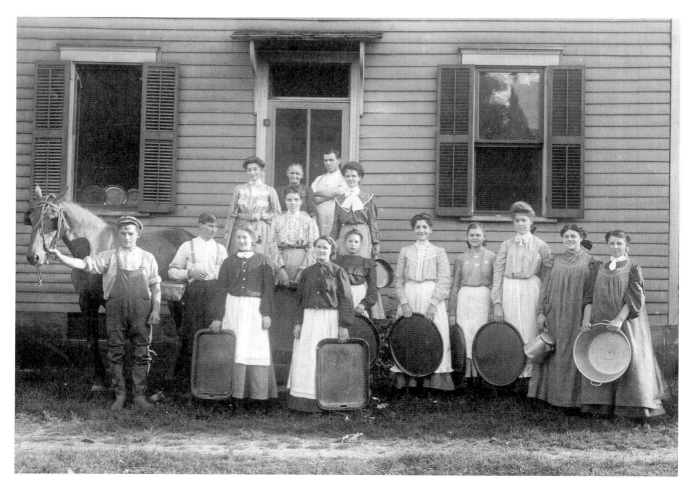

The stolid Zoarites don't take orders of anybody. They put the grub on the table, and you can fill up or retire, just as you like.

—*Iron Valley Reporter* (Dover, Ohio) (August 3, 1872)

Working in the Hotel in its later years was a favored job. Chambermaids and livery boys received cash gratuities to spend as they liked, an opportunity other young Zoarites did not have. And some members grumbled that the best of the Society's produce went to the Hotel and not to deserving Society members. *AV9 Collection.*

A bar is operated in connection with the hotel and although all drinks are free to the residents, not one case of intoxication has been found among the members of the society since its organization.
 —"The Dissolution of the Separatists," *Cleveland Plain Dealer*
 (March 27, 1898)

Outsiders could purchase local beer as well as imported wine at the Hotel bar.
AV9 Collection.

We strolled by the hotel, a large white building, regarded by the entire community as a wonder of size and beauty. The smiling landlord appeared, rubbed his hands, and, in answer to our inquiries, replied: "Gut fare für mann und beast: one feed victuals, twelve cents; we keeps folks for forty-five cents a day, but we allows kein smoke und kein swear; breakfast at six, dinner at twelve, supper at half past five; walk in." So saying he ushered us into a grim parlor, with wooden chairs drawn up in martial array around a large table, and four strange little pictures on the walls, which came from Würtemberg fifty years before.
—Constance Fenimore Woolson, "The Happy Valley,"
Harper's Monthly Magazine (July 1870)

This is Christian Ruof, landlord of the Hotel, in the early 1890s. He and his family received the business after the Dissolution. *Zoar Collection.*

Zoar has always been popular with its neighbors. The country people came in on Sundays to enjoy the novel conditions and have all the fun they could. Sometimes they precipitated disturbances. A grove was set apart for the use of picnic parties. Tramps showed their appreciation of the warm room and free lunch furnished them by calling again. The visitors at the summer hotel, by flashy dress, free use of money, and marvelous tales of another world, unintentionally aroused discontent in the younger generation of the Zoarites.

—George B. Landis, "The Society of Separatists of Zoar, Ohio,"
Annual Report of the American Historical Association (1898)

The Tuscarawas River and Zoar Lake, an old oxbow of the river dammed to form a lake, provided recreation for both visitors and Society members. This boat landing was just north of the sawmill on the river. *P223 Baus Collection.*

The hotel is crowded to-day with cheap merry-makers, who come in buggies with their girls and have dinner, roam around the village, and drive home in the evening. Tanned reapers, awkward in Sunday clothes, with table manners unspeakable.
 —Alexander Gunn, June 26, 1892, *Hermitage-Zoar Note-Book* (1902)

Here a couple inspects the horse barns near the Bauer Haus on Third Street. *P223 Baus Collection.*

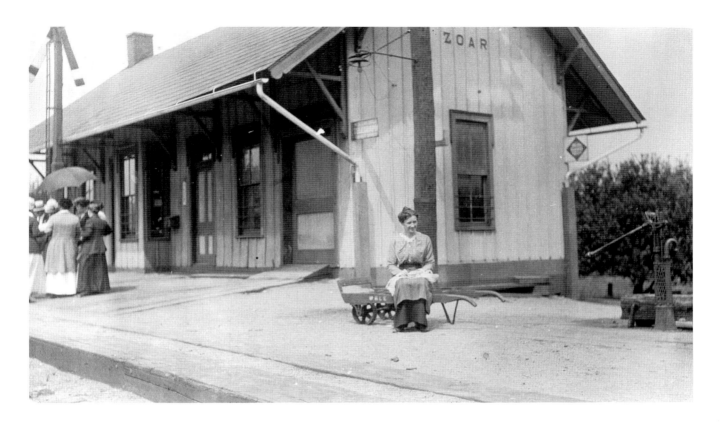

The traveling guests at Zoar are continually growing in number, for everyone who has spent the summer there becomes a voluntary agent of the colony.
 —Karl Knortz, *Aus der Mappe eines Deutsch-Amerikaners* (1893)

Tourism in the late nineteenth century was a leisurely experience. Visitors tended to stay at a resort for long periods of time and return year after year. Fathers might commute back and forth to the city, a trip made easier with the railroad. *AV5 Collection.*

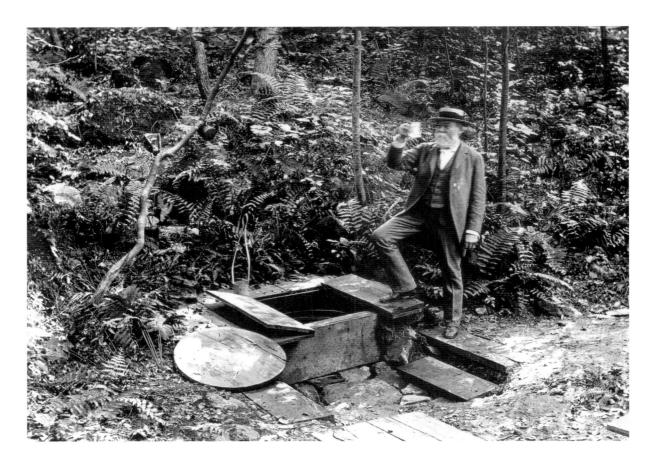

Recently a mineral well was also discovered, about one mile away . . . , the water of which has a taste similar to that of the Landstadt mineral water. Since several female members of the Society who had suffered from rheumatism completely recovered by bathing in this water, a regular house has been built for this purpose . . . in order to accommodate strangers who suffer from the same complaint and are willing to try the water.

—P. F. D., "Harmony Builds the House . . ." (1832)

After the Dissolution several former members formed a corporation to distribute this water but met without success. The man in the photograph is Stephen Buhrer, an orphan who grew up in the Society, moved away, and became mayor of Cleveland, Ohio, from 1867 to 1871. *P365 Properties Collection.*

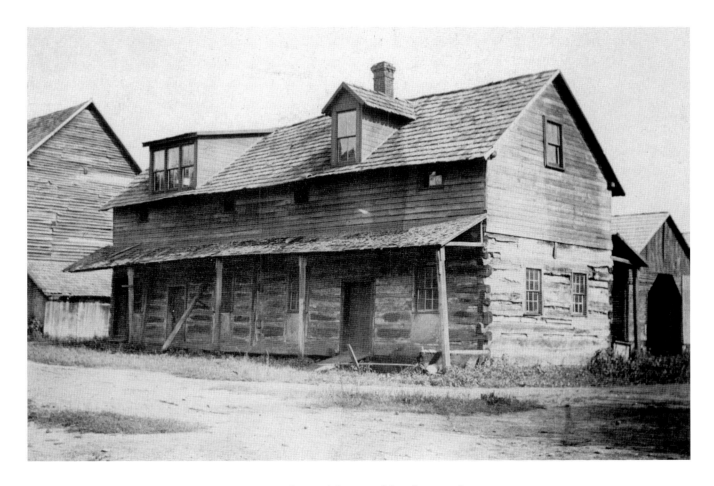

Here in the summer come many visitors to enjoy the restful quiet of the place, and a school of artists, who find in the picturesque houses, the quaint people and the varied beauty of the surroundings, interesting subjects for the brushes and their brains.

—George B. Landis, "The Society of Separatists of Zoar, Ohio," *Annual Report of the American Historical Association* (1899)

The log Meeting House, used only for community activities and storage since the brick one was built in 1853, became an artists' studio in the 1890s. Note the large windows on the northern exposure, the best light for painting. The building was torn down in 1908. *Zoar Collection.*

"A Release from Restraint of the Covenant"

THE DISSOLUTION OF THE ZOAR SOCIETY

The Zoar Society ended because the glue holding it together—their distinctive religion and their memories of persecution—no longer held and because the community was tugged apart by outside forces. Amazingly, the Dissolution was carried out rather amicably; although there were several court cases, all were settled in the Society's favor.

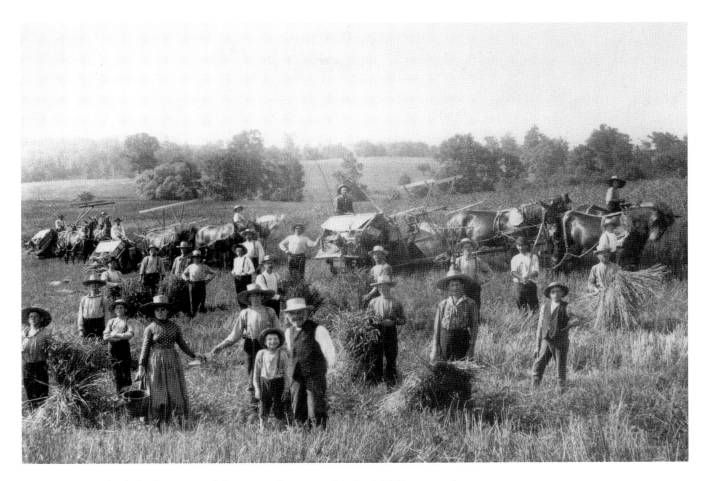

But a year ago [sic] the last man of the original comers, Michael Miller, passed over to the other world; and his departure seemed to release many from the restraint of the old covenant: and ideas that had been held in abeyance sprang into prominence, and there is no doubt in our mind but that these ideas will gain strength till a dissolution of the old methods will prevail.

　　　　　　　　—Editorial, *Iron Valley Reporter* (Dover, Ohio) (March 10, 1898)

Michael Miller (1807–1893, center) was a child of twelve when he, his mother, and his sister arrived in Zoar. Not only had he experienced life in Germany but also the entire history of the Society. After his death no one could remember the beliefs and hardships that had created communal Zoar. *AV9 Collection.*

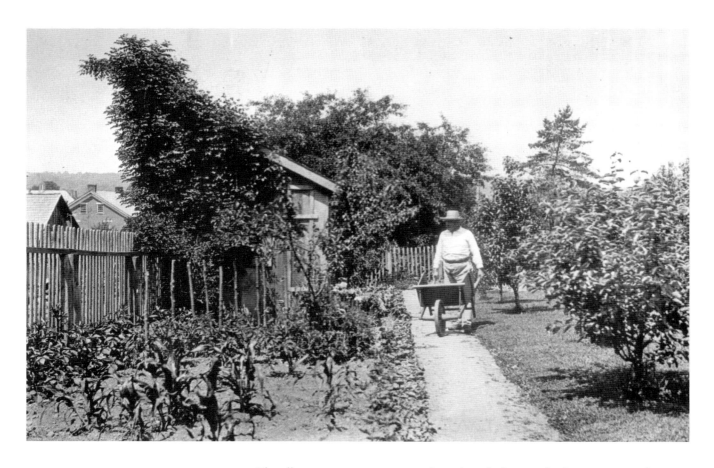

The allotting commissioners are through with their work of appraising, and temporary allotments will be made shortly. Although it may take some time before each member may enter upon work on his own property, they will soon know what share will fall to them. Mr. Alexander Gunn has bought the property which he had rented.
—*Iron Valley Reporter* (Dover, Ohio) (June 30, 1898)

Alexander Gunn was an anomaly in Zoar life. An outsider, he was allowed to live among the Separatists, even though he was the worldliest of men. The calm, peaceful life of Zoar certainly attracted this retired Cleveland industrialist to the village, but his presence caused much internal dissension. Here he tends the garden he cultivated at the Hermitage, the cabin he occupied in Zoar. It is unclear whether he purchased it after the Dissolution, as this quote suggests, or before. *AV9 Collection.*

The present generation sees too clearly that a favored few enjoy all the comforts and luxuries that money can buy, while they must be satisfied with what is meted out to them.

—[Levi Bimeler,] *The Nugitna* (February 24, 1896)

At Zoar Lake Alexander Gunn, reclining, relaxes with his "Three Leaf Clover Club," which included favored members of the Society as well as prominent outsiders. Bimeler wrote his "anti-Gunn" treatises expressly to protest this sort of behavior. *P223 Baus Collection.*

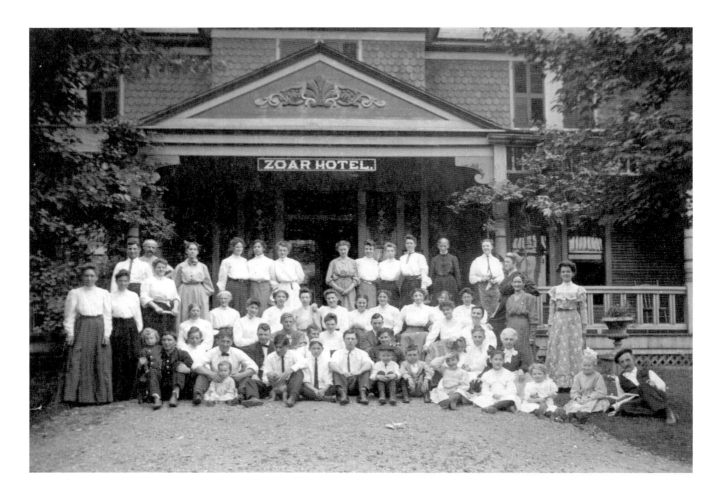

It has been the summer crowding of tourists that has brought unrest and worldliness into the community, and that has made the younger generation ill content with a quiet and uneventful life.

—Robert Shackleton, "In Quaint Old Zoar,"
Godey's Magazine (November 1896)

Perhaps most envied was the outsiders' ability to come and go and not be tied to an economic system that paid only in security, not in cash. If a member left the Society, he was not reimbursed for any labor he had given. *AV9 Collection.*

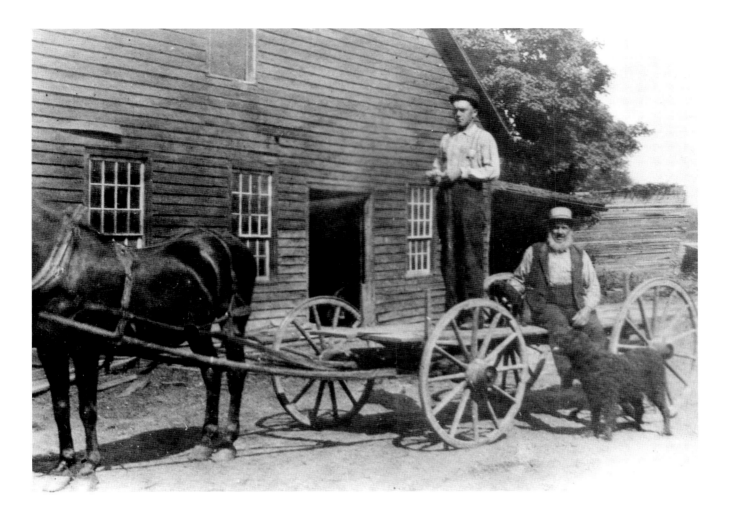

The partition of Zoar is being prepared. The brethren ever more carelessly re-
spond to the bell for labor.
 —Alexander Gunn, May 21, 1898, *Hermitage-Zoar Note-Book* (1902)

A communal society cannot coerce its members to work; they have to want to
work for the good of the association. As the Dissolution drew closer, members
lost their incentive. *P365 Properties Collection.*

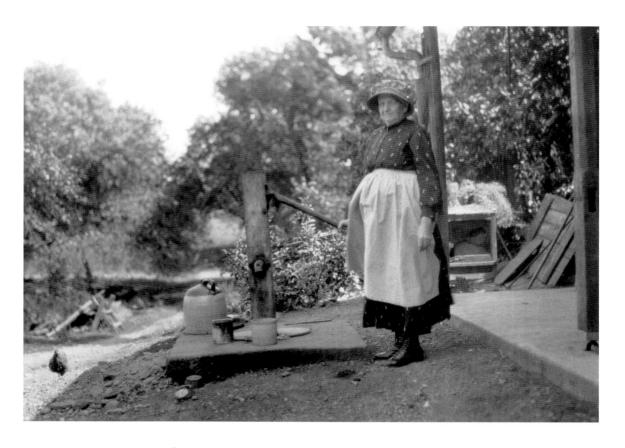

The patriarch . . . did not wish to give up the Zoarite scheme. Communism with him had been and still was a success. This was the sentiment of many of the older members—it was too late for them to launch out into the world on an untried experience for themselves; many of them succumbed reluctantly and apprehensively to the will of the great majority—in the decision to disband. To them it was a life free from care, worry, and excessive work. They literally took no thought for the morrow. They lay down in comfortable homes at night, in certain and satisfactory knowledge that they would be equally well provided for.

—E. O. Randall, *History of the Zoar Society* (1899)

Mrs. Elizabeth Beiter (1851–1944) stands in front of the log Print Shop, where Bimeler's *Discourses* were published. Her job was bleaching cloth and straw hats. Her husband, John, was the blacksmith. *P223 Baus Collection.*

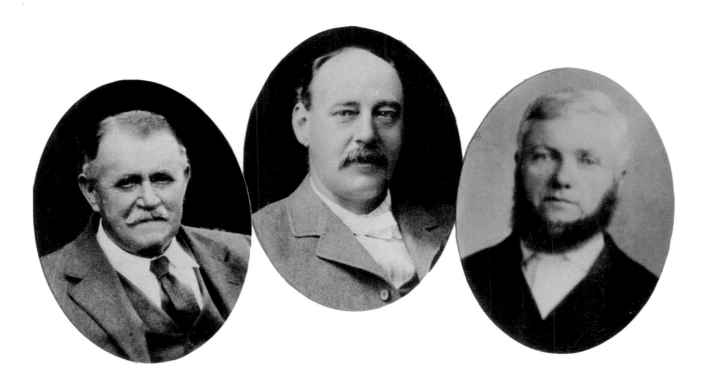

The three present trustees are John Bimeler, John [Joseph] Bereymeir [sic] and Christ [sic] Ruof. Although clothed with almost despotic power they are as democratic as the other members of the society and with them work in the fields.
—"The Dissolution of the Separatists," Cleveland Plain Dealer
(March 27, 1898)

Pictured left to right are Joseph Breymaier, John Bimeler, and Christian Ruof. It was their doleful duty to break up the Society. *P365 Properties Collection.*

The younger generation are in the majority at present and it is they who are arranging for the separation. They want to branch out and make money as rapidly as the people who visit the town every summer.

—"The Dissolution of the Separatists," *Cleveland Plain Dealer* (March 27, 1898)

On March 10th, 1898, all members of our Society agreed upon a dissolution of the corporation known as the "Society of Separatists of Zoar" and upon a division of its property into equal shares. The division and allotment will be made by three disinterested men as soon as a survey and plat of the property can be prepared by a competent surveyor.

—Louis Zimmermann, *Iron Valley Reporter* (Dover, Ohio) (March 17, 1898)

Louis Zimmermann was Treasurer (or Cashier) of the Society at the time of the Dissolution and therefore in charge of parceling out the funds. He was, perhaps unfairly, the focus of much complaint by disgruntled former members of the Society who felt they did not get their due shares. *P365 Properties Collection.*

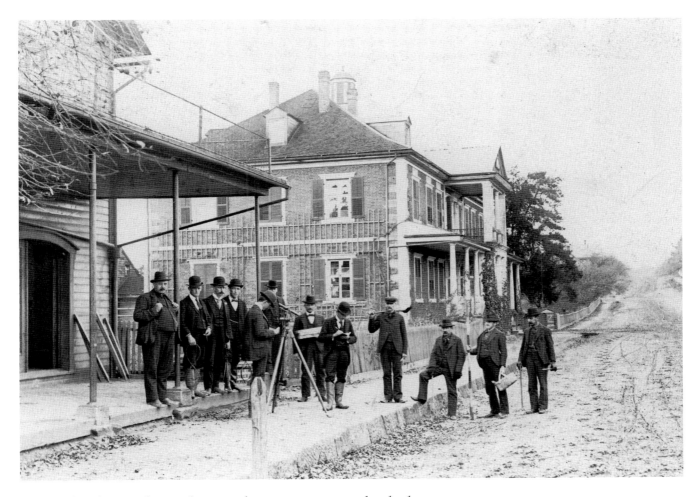

On March 10th, 1898, the members signed a written compact, whereby the members "selected and appointed Samuel Foltz, Henry S. Fisher and William Becker, commissioners to make said partition and division and to designate in their report and statement by numbers and on a plat to be prepared by George E. Hayward, the Surveyor selected by us, the parts and portions of said real estate which each of us is to receive as our respective shares and allotments."

 —E. O. Randall, *History of the Zoar Society* (1899)

Here is the survey team in front of the Town Hall on its way to divide the more than 7,000 acres owned by the Society. *Zoar Collection.*

The farm lands were apportioned into the requisite number of lots according to the appraised value of respective sections. That is, had the land been uniform in value each distributee would have received some fifty odd acres. But as the land varied greatly in fertility, accessibility, etc., the survey, appraisal and division produced allotments of unequal number of acres, but supposed equality of value. Each member got an equal amount of cash and a section of farm land and a home or property in the village.

—E. O. Randall, *History of the Zoar Society* (1899)

Today this map is still used by the Tuscarawas County Recorder to determine land ownership. *Zoar Collection.*

The sale of Zoar chattels continues. A crowd of country people, only a few of whom have any idea of purchase—they eye me curiously. . . . The field opposite my house is filled with implements—wagons, cider-tanks, and every kind of rustic gear. The auctioneer, with incredible fluency, urges the rustics to bid. His gestures would make a stump orator frantic that he could not equal them. He talks in every fiber of his organization. Some women linger about, draggled in the wet grass. Some of the old members move about, dazed to see the ancient objects scattered.
—Alexander Gunn, Ocotber 5, 1898, *Hermitage-Zoar Note-Book* (1902)

Only the common property was auctioned. Furniture and household goods were kept by each family. It was difficult, however, for those members without money to buy at the auction the objects needed to farm the property they had just been granted. *AV9 Collection.*

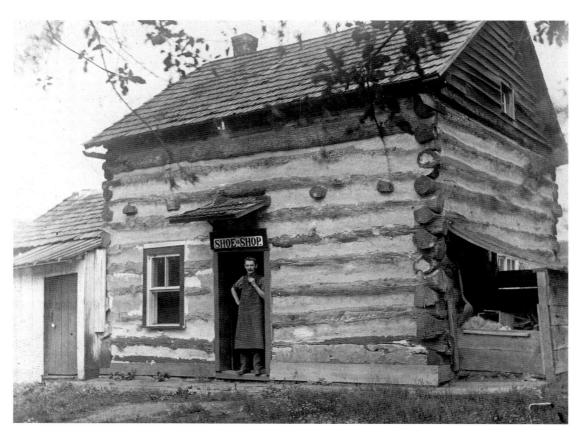

The cheery master cobbler had established himself in the ancient log church which dated back to the early years of the colony, and was probably the oldest structure in the village, and for many years had been used as a storage room. He told me one of his two assistants had abandoned the leather bench for the farmer's plow. The other "help hand" had opened a new and rival establishment. It was the first, and indeed, the only case of competition ever experienced in Zoar.

—E. O. Randall, *History of the Zoar Society* (1899)

Jacob Sylvan stands in the doorway of the Joseph Bimeler Cabin that also served as the first church until a larger log structure was built in 1820. Finding an occupation in a town as small and as isolated as Zoar was difficult indeed. Many young people sold their land and left the village for city life. *P365 Properties Collection.*

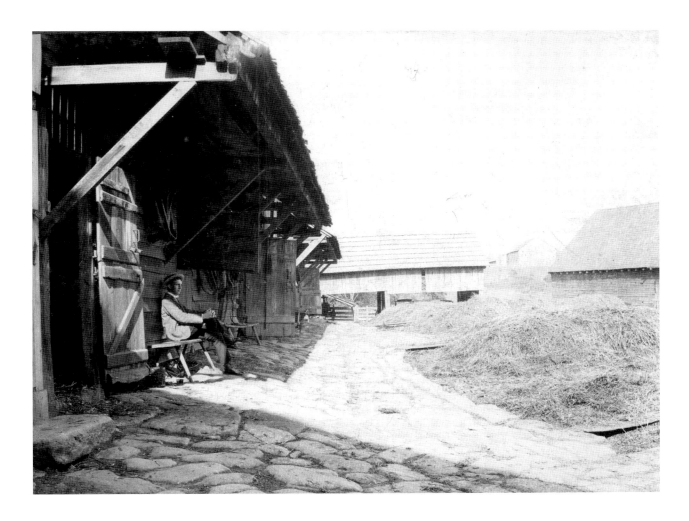

The huge horse stables, cow stable and sheep stable were like great banquet halls deserted.

—E. O. Randall, *History of the Zoar Society* (1899)

Randall, secretary of the Ohio Archaeological and Historical Society (now the Ohio Historical Society), came to Zoar just before the Dissolution and again a year afterward. He provides a rare glimpse into Zoar life in transition. Many agricultural and industrial buildings fell into ruin after the demise of the Society. *P365 Properties Collection.*

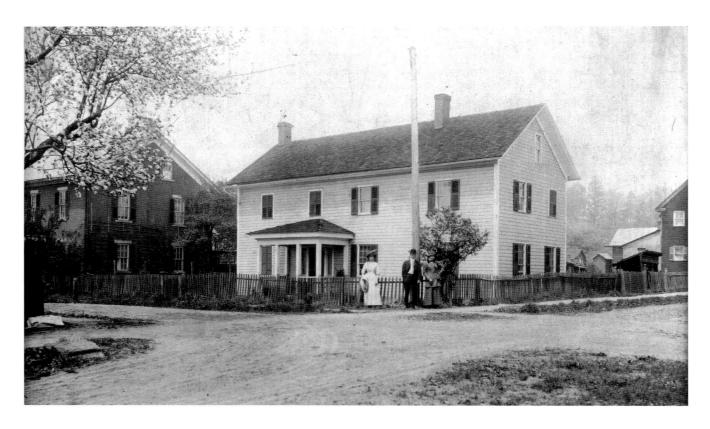

Some say we are an ungrateful one for writing things for publication which should remain with us dear fools only, that the world may think everything was smooth sailing and immensely just and satisfactory. And they may be right, for why should we say anything when we only lose the cherry tree which our great-grandfather planted; and when only two-thirds of our wash-house and wood-shed and accessories go to our neighbor; and when our coal-house is cut in two; and when we have to spend $60 this week for a new roof in order to save the ceiling from falling on us while we sleep, etc. And for all these blessings we are called ungrateful.
—[Orthoford Kappel, correspondent] *Iron Valley Reporter*
(Dover, Ohio) (October 13, 1898)

Not everyone was happy with his or her share in the Dissolution. Some houses were divided in two, and even though this was common earlier, it made for difficulties when it was now private property. *AV9 Collection.*

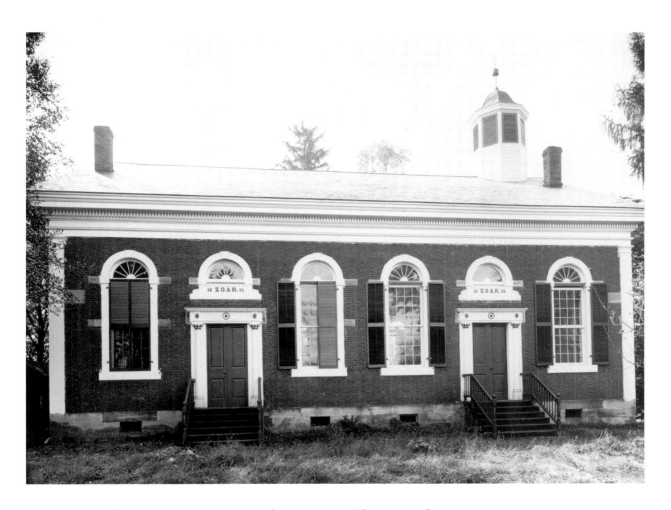

The brotherhood is rent in two factions over the possession of the meeting-house;
one, under the restless schoolmaster, favors complete occupation, with a settled
Lutheran preacher; the other refuses to yield all right.
 —Alexander Gunn, January 13, 1899, *Hermitage-Zoar Note-Book* (1902)

Ultimately the Separatists did not again become Lutherans and instead found
a nearby minister of the German Reformed Church who met their needs—
namely, he could preach in German. However, this compromise was not reached
until after four years of wrangling. The Zoar United Church of Christ cele-
brated its centennial in 2002. *P365 Properties Collection.*

Authors and Photographers of Zoar First-Person Accounts

M[ichael] B. Bateham (ca. 1813–ca. 1860). Bateham published the *Ohio Cultivator,* a magazine for farmers, from 1845 to 1856, when he sold it to Colonel S. D. Harris. He was active in horticultural circles in the Columbus area, being secretary of the Columbus Horticultural Society, and he helped start the Franklin County Fair in 1846 and the Ohio State Fair in 1850.

Louis Baus (1875–1949). Baus, a Cleveland native, was a professional photographer with the *Cleveland Plain Dealer* and an amateur photo historian. He collected photographs not only of Zoar but of Great Lakes shipping, the Ohio & Erie Canal, the Shakers, and Cleveland firefighters. His photos, many of them copied from older originals, were the basis of lantern-slide lectures given to the public.

Geoffrey Williston Christine. Nothing is known about this author of the 1889 article for *Peterson's Magazine*.

P. F. D. The name of the author of "Harmony Builds the House . . ." is unknown. The manuscript is part of the Peter Kaufmann Papers (MSS 136) at the Ohio Historical Society and was translated from German by Wolfgang Fleischhauer of Ohio State University. P. F. D. was not a member of the Separatists but must have lived among them for a time. The article may have been

written to appear in one of the German periodicals printed by Kaufmann, a Canton publisher who was interested in communalism.

Alexander Gunn (1837–1901). Gunn was a wealthy retired Cleveland industrialist, "a familiar figure in European watering places," when he discovered Zoar in 1879. For the rest of his life he lived off and on in the village, staying at first at the Zoar Hotel. Later he rented the Hermitage, an 1817 log cabin, and spent time hosting parties, drinking with the Zoar Society Trustees, and cultivating his garden. His influence with the Trustees was such that many other members blamed him for the Zoar Society's eventual Dissolution. After his death in Germany, his friend William Whitney found a journal of three small notebooks recording his experiences in Zoar and elsewhere from 1889 to 1901. Edited by Don Carlos Seitz of the *New York World* and privately printed in two small editions, the *Hermitage-Zoar Note-Book* gives a glimpse of life in Zoar by one of the few outsiders allowed to live within the closed community.

George Washington Hayward. Hayward's diary of his travels from Easton, Massachusetts, to Zanesville, Ohio, in 1829 is the first mention of the Zoar Greenhouse.

William Alfred Hinds (1833–1910). Hinds was a member of the Oneida Community, the Perfectionist communal society (1848–81) headed by John Humphrey Noyes in Oneida, New York. As such he was the editor of the *Oneida Circular* and *The American Socialist*, and his travels for the newspapers resulted in the book *American Communities* (1878). After Oneida's dissolution, Hinds became a director, and later president, of Oneida, Ltd., a community enterprise that still exists today as the world's largest manufacturer of flatware.

Henry Howe (1816–1893). Howe was born in New Haven, Connecticut, into a literary family. His father, a Yale bookstore owner, published the first edition of Noah Webster's *Dictionary*. His reading of J. W. Barber's 1836 *Connecticut Historical Collections* influenced his life work of documenting the history of the emerging American republic. His first book, *Eminent Americans*, was published in 1839. He wrote histories of New Jersey (1841), Virginia (1845), and *Historical Collections of Ohio* (3 vols., 1847) while "zigzaging [*sic*] from county seat to county seat," in the words of his biographer. After settling in Cincinnati

in 1847, he continued to write books on the West, the ocean, and American history. His Ohio book was revised in 1885 and sold by subscription; after a financial setback, the copyright and plates were purchased by the Ohio legislature and the book was published in 1891.

Warren Jenkins. Jenkins published the *Ohio Register & Anti-Masonic Review* newspaper with Elijah Glover from 1830 to1833 during the height of anti-Masonic fervor. His first version of the *Ohio Gazetteer,* a combination guidebook and geographical dictionary, was published in 1837 and revised in 1841. The *Gazetteer* was a revision of an earlier work by James Kilbourne, published in 1829.

Karl Knortz (1841–1918). Knortz was instrumental in acquainting Germans with American literature, including works by Whitman and Longfellow. Educated in Germany, he came to America in 1863, becoming a teacher and German-language newspaper editor. This translation of his 1893 Zoar article was found in the papers of E. O. Randall, who used it for his own work on Zoar.

J. B. L. This may be Julian Lane, son of the *Akron Beacon* (now *Akron Beacon-Journal*) publisher Samuel A. Lane.

George B. Landis (ca. 1868–1955). Landis, a native of Newville, Pennyslvania, was a recent graduate of Findlay and Oberlin Colleges when he wrote his monograph on Zoar in 1898. He spent his adult life working for the national YMCA.

Maximilian, Prince of Wied (1782–1867). Maximilian, prince of a small German principality, had a desire from early boyhood to explore. After distinguished service as a major-general in the Prussian army at the Battle of Jena, he followed his scientific bent for the rest of his life, first traveling to Brazil and later to the interior of North America in 1832. On the latter trip he was accompanied by the artist Charles Bodmer, who left a stunning record of the Native Americans they encountered. It was on their trip home in 1834 that they traveled through Zoar by way of the Ohio & Erie Canal.

Charles Nordhoff (1830–1901). Nordhoff was born in Prussia and came to the United States at age five, settling in Cincinnati. As a youth he was apprenticed

to a printer in Philadelphia. He enlisted in the U.S. Navy in 1844 and continued to work on ships around the world after his enlistment. At age twenty-three he took up journalism, eventually becoming an editor at Harper Brothers and the *New York Post* and writing works on seafaring life. He resigned from the *Post* in 1871 and traveled west, becoming a correspondent for the *New York Herald* in 1874. His book *Communistic Societies of the United States* has been called a "valuable contribution to the social history of the U.S." He later wrote on the South during Reconstruction, as well as several children's books.

Pipsey Potts (1827–1888). Rosella Rice was born in Perrysville, Ohio, and wrote for local papers at an early age. She later became a lecturer and contributor to national magazines and newspapers, assuming the nom de plume of Pipsey Potts.

Moses Quinby (1810–1875). Quinby was born in North Castle, New York. In 1831 he kept a diary as he traveled from his home to Massillon, Ohio, passing through Zoar. Later he became known as the founder of commercial beekeeping in America with his book *Mysteries of Beekeeping Explained* (1853).

E[milius] O[viatt] Randall (1850–1919). Randall was born in Richfield, Ohio, and was admitted to the Ohio Bar in 1890. He was a professor of law at Ohio State University from 1893 to 1909; he was also secretary of the Ohio Archaeological and Historical Society from 1894 until his death and editor of its *Quarterly* journal. In addition, he wrote *Mound Builders of Ohio* (1908) and a five-volume *History of Ohio* (1912) and edited multiple volumes of Ohio Supreme and Appellate Court decisions.

Sophia Willard Dana Ripley (1803–1861). Ripley was the wife of George Ripley (1802–1880), minister, philosopher, and Transcendentalist. Together with Ralph Waldo Emerson and Margaret Fuller the Ripleys helped found the Transcendentalist periodical *The Dial* in 1840. It is thought that the visit to Zoar in the spring of 1841, recounted in *The Dial* and later reprinted in Horace Greeley's *New Yorker* (quoted here), was in preparation for the founding of the group's Brook Farm later that year, a communal experiment that, although a failure, involved many prominent New Englanders. After Brook Farm's 1847 demise, Sophia was a teacher in New York until her death.

Robert Shackleton (1860–1923). Shackleton was born in Wisconsin and was admitted to the Ohio Bar in 1881. In 1890 he moved to New York and worked for newspapers and magazines. He edited the *Saturday Evening Post* from 1900 to 1902. His freelance career after that date included children's and travel books, some coauthored with his wife.

Constance Fenimore Woolson (1840–1894). Woolson was born in Claremont, New Hampshire, and is a descendant of the author James Fenimore Cooper. She moved to Cleveland, Ohio, as a child and accompanied her father on long drives through Ohio (which included stays at the Zoar Hotel), Wisconsin, and Mackinac Island, all of which would become scenes for her writing. After her father's death she was forced to turn to her pen to make a living. "The Happy Valley" was her first published article and one of many travel sketches. *Castle Nowhere* (1875) contains two other short stories based on her time in Zoar, "Wilhelmina" and "Solomon." She and her mother moved to St. Augustine, Florida, and she later went to Europe for the remainder of her life. She is noted for evoking "local tone" and was admired by Henry James and other contemporary authors.

Works Cited

Primary Sources

[Bateham, M. B.] *Ohio Cultivator* 4 (August 15, 1848): 118.

[Bimeler, Levi.] *The Nugitna,* February 24, 1896.

Christine, Geoffrey Williston. "Zoar and the Zoarites." *Peterson's Magazine* 95,
 1 (January 1889): 33–39.

"The Colony of Zoar." *Penny Magazine* (London) 6 (October 26, 1837): 411–12.

"The Dissolution of the Separatists." *Cleveland Plain Dealer,* March 27, 1898.

"A German Village in Ohio." *Portland (Maine) Tribune,* November 25, 1843.
 264.

Gunn, Alexander. *The Hermitage-Zoar Note-Book and Journal of Travel.* 2 vols.
 1878. New York, 1902.

Hayward, George Washington. "Journal of a Trip to Ohio." September 26, 1829.
 278–79. Ohio Historical Society Library.

Hinds, William Alfred. *American Communities.* Rev. ed. Chicago: Charles H.
 Kerr and Co., 1902.

Howe, Henry. *Historical Collections of Ohio.* Vol. 2. 1847. Cincinnati: C. J.
 Krehbiel and Co., 1908.

J. B. L. "The 'Zoar-ites' or Separatists." *Summit Beacon* (Akron, Ohio), July 31,
 1862.

Jenkins, Warren. *The Ohio Gazetteer and Traveller's Guide.* Columbus: Isaac
 N. Whitney, 1841.

Knortz, Karl. *Aus der Mappe eines Deutsch-Amerikaners. Frommes und Got-
 tleses.* Bamberg, Germany, 1893.

Landis, Geroge B. "The Society of Separatists of Zoar, Ohio." *Annual Report of the American Historical Association*, 1899. 165–220.

Maximillian, Prince of Wied. *Travels in the Interior of North America, Vol. III.* 1834. In *Early Western Travels.* Ed. Ruben Gold Thwaites. Vol. 24. Cleveland: Arthur Clark Co., 1905. 154–56.

*Nordhoff, Charles. *Communistic Societies of the United States.* 1875. New York: Dover Publications, 1966.

P. F. D. "Harmony Builds the House . . ." 1832. Peter Kaufmann Papers, MSS 136. Ohio Historical Society Library.

Potts, Pipsey [Rosella Rice]. "A Queer, Quaint People." *Arthur's Home Magazine* 50: Part I (May 1882): 312–14; Part II (June): 371–74; Part II (July 1882): 428–31.

Quinby, Moses. "Diary." October 12–13, 1831. MSS 217, Division of Rare Manuscript Collections, Cornell University Library, Ithaca, New York.

*Randall, E. O. *History of the Zoar Society from its Commencement to its Conclusion: A Sociological Study in Communism.* Columbus: Press of Fred J. Heer, 1899. (Also contains reprints of Levi Bimeler's *Nugitna.*)

[Ripley, Sophia Dana]. "A Western Community." *New Yorker* 11 (July 17, 1841). (Originally printed in *The Dial* 2, 1 (July 1841).

"The Separatist Society." *Ohio Statesman,* September 18, 1859.

Shackleton, Robert. "In Quaint Old Zoar." *Godey's Magazine,* 123, 707 (November 1896): 511–17.

Woolson, Constance F. "The Happy Valley." *Harper's Monthly Magazine* 41, 242 (July 1870): 282–85.

Other Works on Zoar

Durnbaugh, Donald F. "Strangers and Exiles: Assistance Given by the Religious Society of Friends to the Separatist Society of Zoar." *Ohio History* 109 (Winter/Spring 2000).

Fritz, Eberhard. "Roots of Zoar, Ohio, in Early 19th Century Württemberg: The Separatist Group in Rottenacker and Its Circle—Part One." *Communal Societies* 22 (2002).

*Hickman, Janet. *Zoar Blue.* New York: Macmillan, 1978. (A juvenile novel on the Civil War in Zoar.)

*Morhart, Hilda D. *The Zoar Story.* Dover, Ohio: Seibert Printing Co., 1967.

Nixon, Edgar B. "The Society of Separatists of Zoar." Ph.D. diss. Ohio State University, 1933.

*Ohio Historical Society. *Zoar: An Ohio Experiment in Communalism.* Columbus: The Ohio Historical Society, 1952.

Webber, Philip. "Jakob Sylvan's Preface to the Zoarite Anthology, *Die Wahre Separation, oder die Wiedergeburt,* as an Introduction to Un(der)studied Separatist Principles." *Communal Societies* 19 (1999).

Available for sale at the Zoar Village State Memorial.

Index